The Ultimate Guide to
MANGA FASHION

RABIMARU

TUTTLE Publishing

Tokyo | Rutland, Vermont | Singapore

CONTENTS

CHAPTER 1 Casual Basics

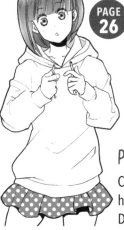

T-Shirts

Basic shape and creases/Women's tops & T-shirts/Finding the right fit/ Depicting different physiques

PAGE 8

Other Shirts

Long-sleeved shirts/ Sweatshirts/Sweatshirts (loose silhouettes)

PAGE 20

PAGE 16

Collared Shirts

Shape around the collar/ Comparing collars with and without stands/Drawing a collared shirt using a T-shirt as a base/ Various collars

Pants

Basic fabrics/Basic shapes/ Variations/Combined designs/ Tricks for expressing wrinkles in pants/Drawing denim/Drawing sweatpants and trackpants/Drawing wide-legged pants/Drawing other pants/Drawing pants for different bodies/Movement and creasing

PAGE 38

PAGE 26

Parkas & Hoodies

Capturing the shape of the hood/Types of hoodies/ Different necklines/ Differences in hood shape

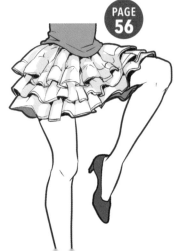

PAGE 56

Skirts

Basic skirt shapes/Other variations/ Wrinkles in skirts/The differences between gathers, frills, flares and draping/Skirts in motion/Build on the skirt to draw a dress

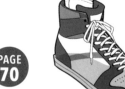

PAGE 70

Sneakers

Types of sneakers/Basic drawing method/Drawing various angles/ Differences in silhouettes/Simplified shoes/How to draw shoelaces

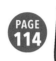

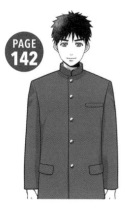

Understanding Garment Construction

If you don't feel as if you're improving when drawing characters' clothing, it might be because you're simply trying to draw things as you see them. Once you grasp clothing's construction, the structure of the garment you're trying to draw and why creases form, drawing a range of garments will become much easier.

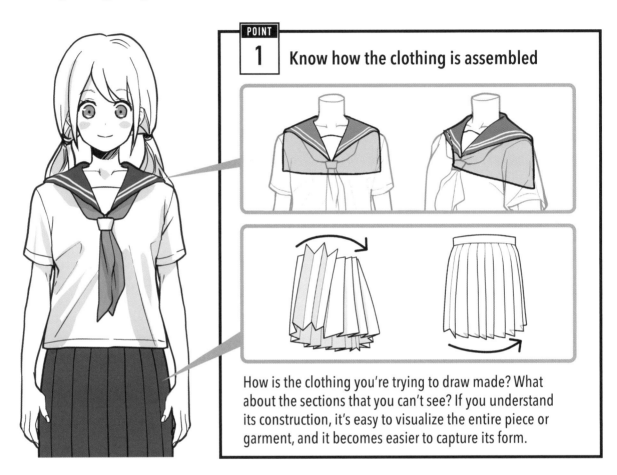

POINT

1 Know how the clothing is assembled

How is the clothing you're trying to draw made? What about the sections that you can't see? If you understand its construction, it's easy to visualize the entire piece or garment, and it becomes easier to capture its form.

POINT

2 Understand what causes creases to form

If you draw creases simply as you see them on actual clothing, the result tends to look rumpled and messy. Understanding what kinds of creases are formed when parts of clothing are pulled taut allows you to capture the small folds and contours realistically.

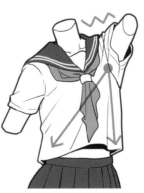
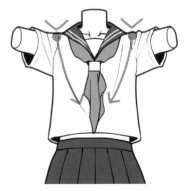

If you grasp the construction of these items, you'll be able to visualize the form of the clothing even if the character moves or the angle changes. Additionally, following the tips below will allow you to freely draw the shape of garments from various angles and poses.

POINT 3 — Start with a simple block shape

If you only pay attention to the small details, you'll become confused and the item will be difficult to draw. The trick is to draw a simplified block form and figure out the overall shape before delving into the details.

POINT 4 — Capture a garment's flow

When covering a body in motion, the fabric in clothing drapes or is pulled taut, creating a sense of flow. Particularly for poses with movement, capturing the flow of the fabric is the trick to expressing a sense of dynamism.

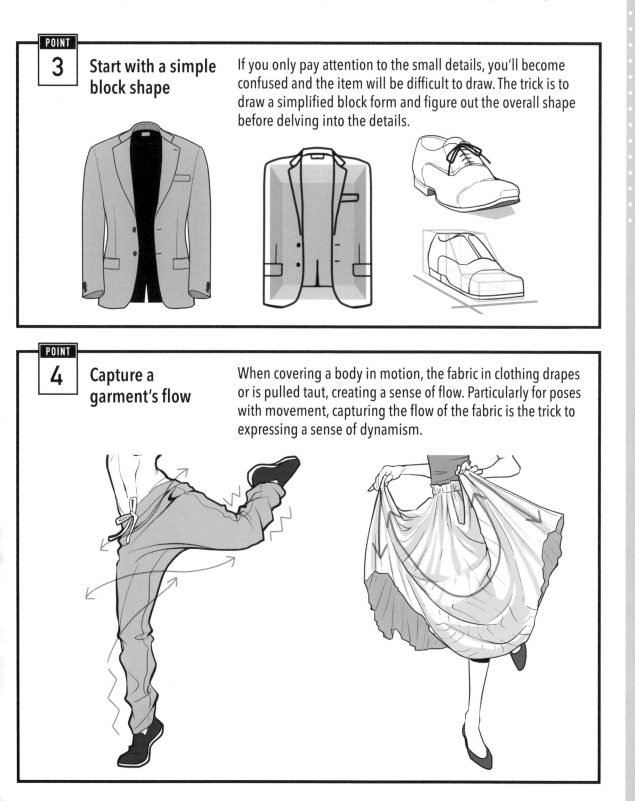

Art and fashion fuse to create amazing characters!

Anyone who draws manga or creates anime dreams of dressing the characters they've created in stylish attire and cool fashions. And for you cosplayers out there, it's fun to pull from a range of sources and inspirations when constructing your own fierce and fabulous creations!

But when it comes to the design phase, the initial stages, many people find it difficult to reproduce garments realistically, with their many creases and wrinkles. The way clothes change shape when a character moves or strikes a memorable pose is another sometimes daunting challenge.

But if you can grasp basic garment construction and repeatedly practice drawing a range of items, you'll soon be on the path to improving your skills. As clothing is made by sewing pieces of fabric together, there are principles governing how the garment's shape changes and how creases form.

For that perfect pose, indelible impression or amazing entrance, clothe your characters in the original outfits and exciting ensembles your careful creations deserve. Enjoy!

Casual Basics

Casual clothes and flexible separates for everyday situations: the silhouette created and the way creases form depend on the material and size of the garment. Get a grasp of each garment's characteristics and construction to differentiate them in your drawings. Your character's personality and quirks are suggested by the distinctive clothes they wear.

T-Shirts

The T-shirt, it could be argued, is the foundation of casual fashion. The soft texture of the fabric is suggested by using mainly curved lines to depict the contours, folds and creases.

Basic shape and creases

⊙ Front section

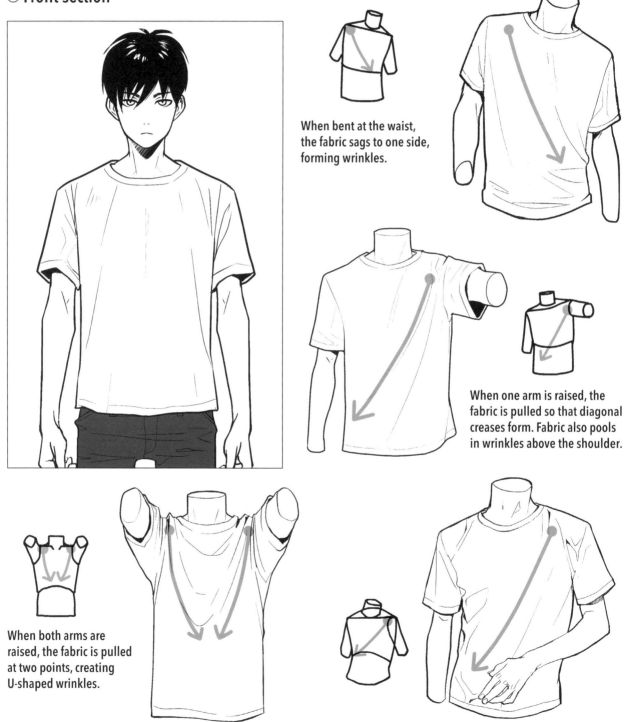

When bent at the waist, the fabric sags to one side, forming wrinkles.

When one arm is raised, the fabric is pulled so that diagonal creases form. Fabric also pools in wrinkles above the shoulder.

When both arms are raised, the fabric is pulled at two points, creating U-shaped wrinkles.

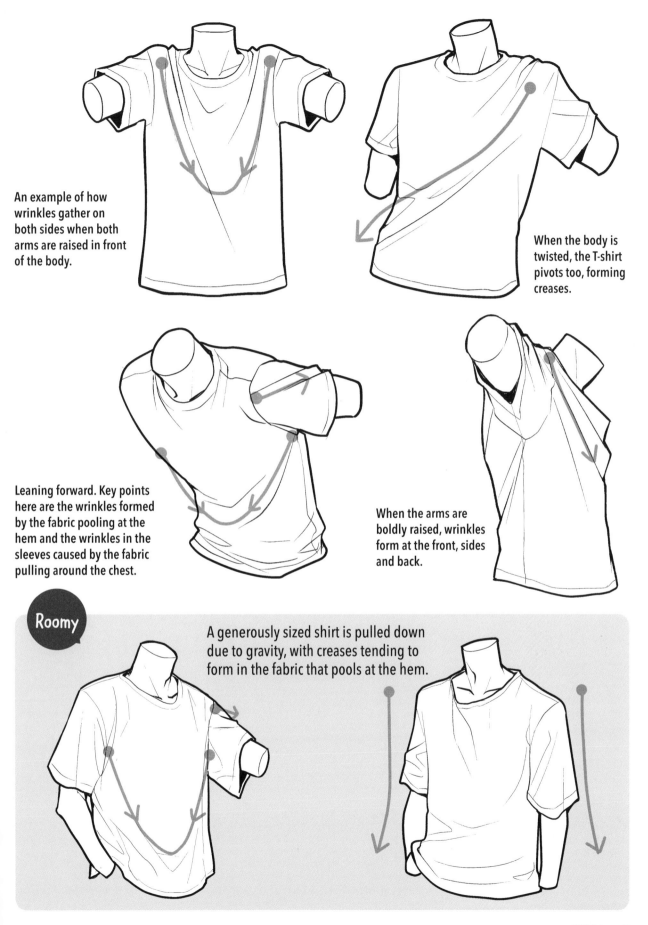

An example of how wrinkles gather on both sides when both arms are raised in front of the body.

When the body is twisted, the T-shirt pivots too, forming creases.

Leaning forward. Key points here are the wrinkles formed by the fabric pooling at the hem and the wrinkles in the sleeves caused by the fabric pulling around the chest.

When the arms are boldly raised, wrinkles form at the front, sides and back.

Roomy

A generously sized shirt is pulled down due to gravity, with creases tending to form in the fabric that pools at the hem.

⊙ Side

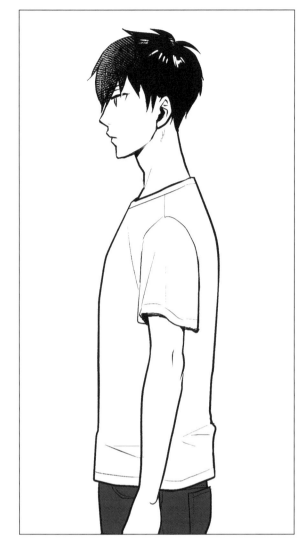

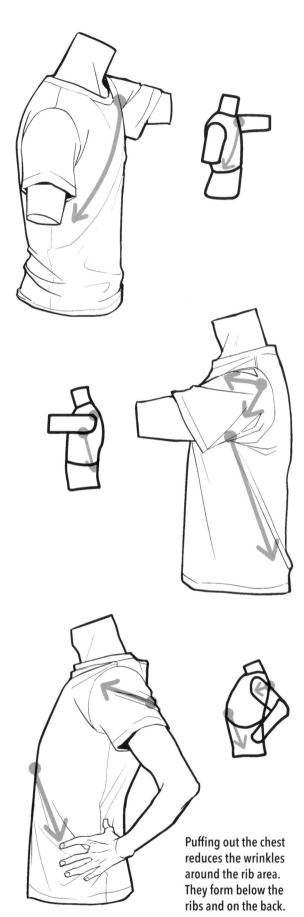

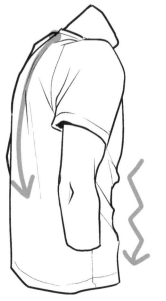

Rounding the back causes the fabric to gather at the stomach, forming creases.

Puffing out the chest reduces the wrinkles around the rib area. They form below the ribs and on the back.

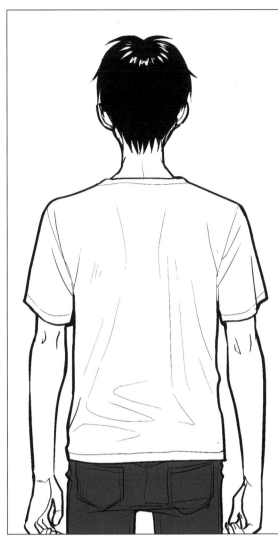

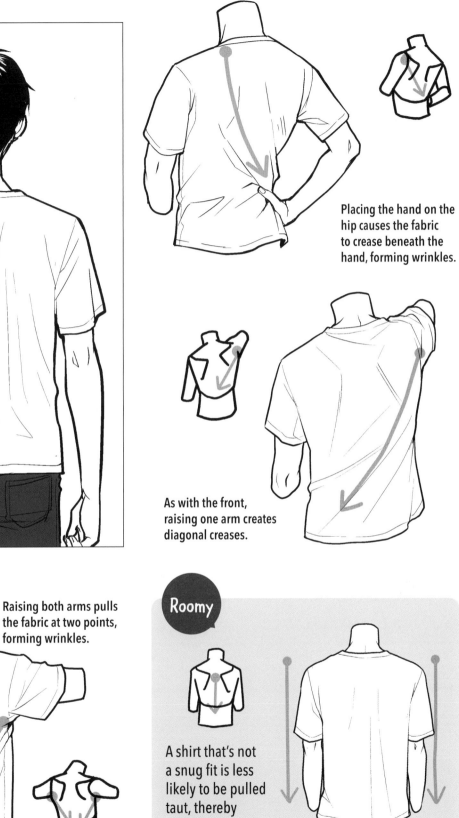

Placing the hand on the hip causes the fabric to crease beneath the hand, forming wrinkles.

As with the front, raising one arm creates diagonal creases.

Raising both arms pulls the fabric at two points, forming wrinkles.

Roomy

A shirt that's not a snug fit is less likely to be pulled taut, thereby creating fewer wrinkles.

Women's tops & T-shirts

When the fabric is pulled taut at the chest, wrinkles are created in the surrounding area. Learning how they form in women's garments is helpful in achieving the right silhouette.

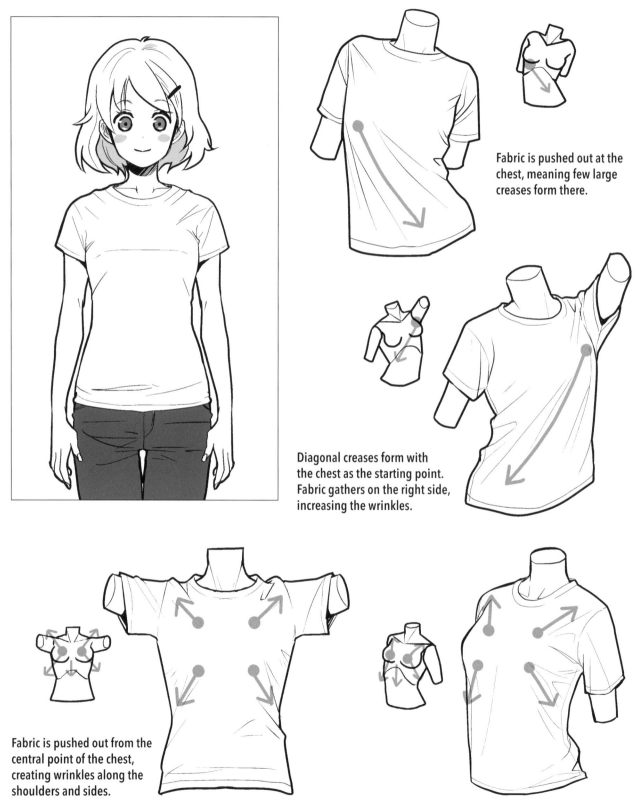

Fabric is pushed out at the chest, meaning few large creases form there.

Diagonal creases form with the chest as the starting point. Fabric gathers on the right side, increasing the wrinkles.

Fabric is pushed out from the central point of the chest, creating wrinkles along the shoulders and sides.

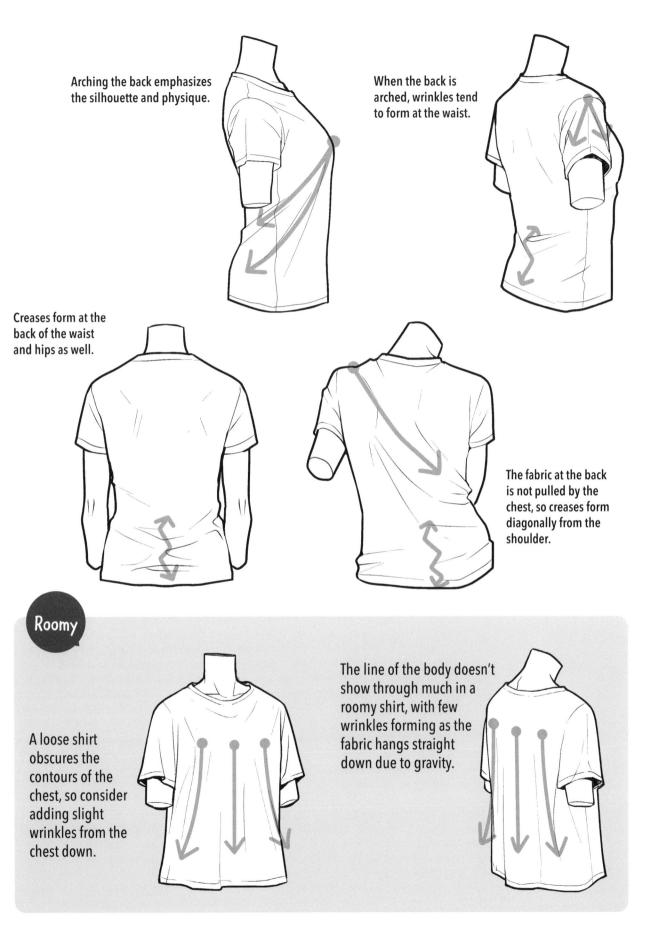

Arching the back emphasizes the silhouette and physique.

When the back is arched, wrinkles tend to form at the waist.

Creases form at the back of the waist and hips as well.

The fabric at the back is not pulled by the chest, so creases form diagonally from the shoulder.

Roomy

A loose shirt obscures the contours of the chest, so consider adding slight wrinkles from the chest down.

The line of the body doesn't show through much in a roomy shirt, with few wrinkles forming as the fabric hangs straight down due to gravity.

Finding the right fit

The silhouette of the shirt and the way wrinkles form depends on the shirt size and the thickness of the fabric. Let's look at some comparisons.

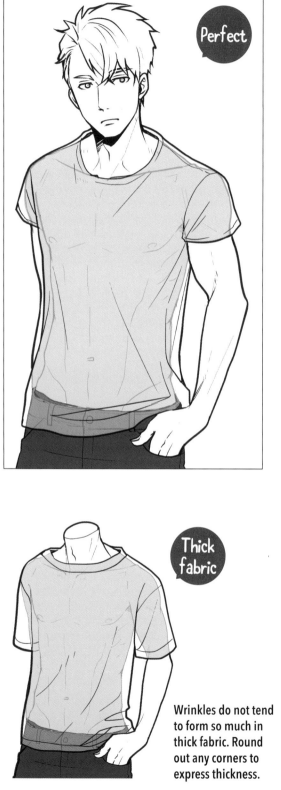

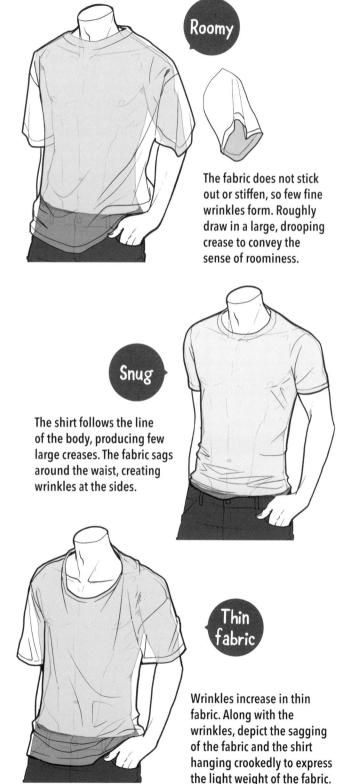

Roomy

The fabric does not stick out or stiffen, so few fine wrinkles form. Roughly draw in a large, drooping crease to convey the sense of roominess.

Snug

The shirt follows the line of the body, producing few large creases. The fabric sags around the waist, creating wrinkles at the sides.

Thick fabric

Wrinkles do not tend to form so much in thick fabric. Round out any corners to express thickness.

Thin fabric

Wrinkles increase in thin fabric. Along with the wrinkles, depict the sagging of the fabric and the shirt hanging crookedly to express the light weight of the fabric.

Depicting different physiques

For those with more defined chests or larger breasts, the fabric is pulled tight, while on other physiques, it's not as taut and hangs more loosely. Let's take a look at the shape and creasing for each type.

Physique 1

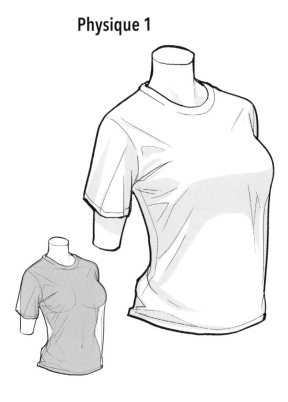

Physique 2

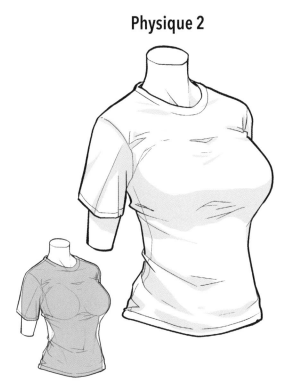

Physique 3

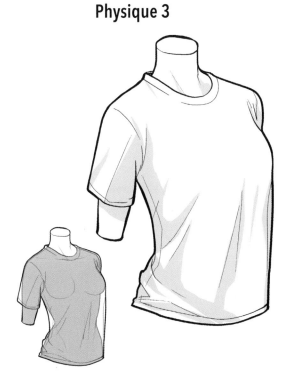

Physique 4

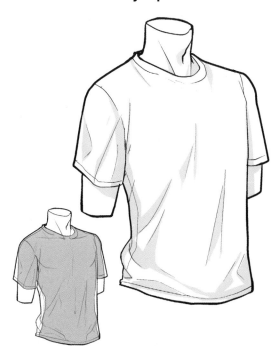

Collared Shirts

Of the various types, polo shirts with collars and cuffs in a ribbed-knit fabric are easy to move around in. The key to drawing them is accurately capturing the structure of the collar.

Shape around the collar

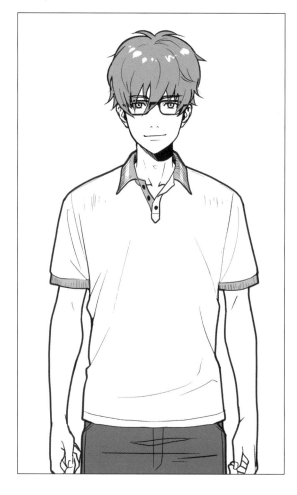

It's easier to capture the shape by drawing in the section at the back that is not visible, as it's hidden by the neck.

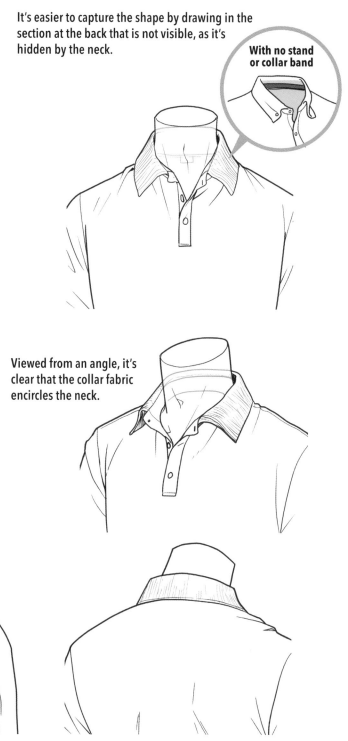

With no stand or collar band

Viewed from an angle, it's clear that the collar fabric encircles the neck.

Viewed from the side, the location of the first button seems to protrude forward.

Comparing collars with and without stands

When it comes to collared shirts, some have a part called a "stand" and others don't. Polo shirts don't have stands, and it's usual for the collar and cuffs to be made of a rib knit. The appearance and drawing method are different for shirts with and without collars, so let's take a look at them here.

When the collar is up

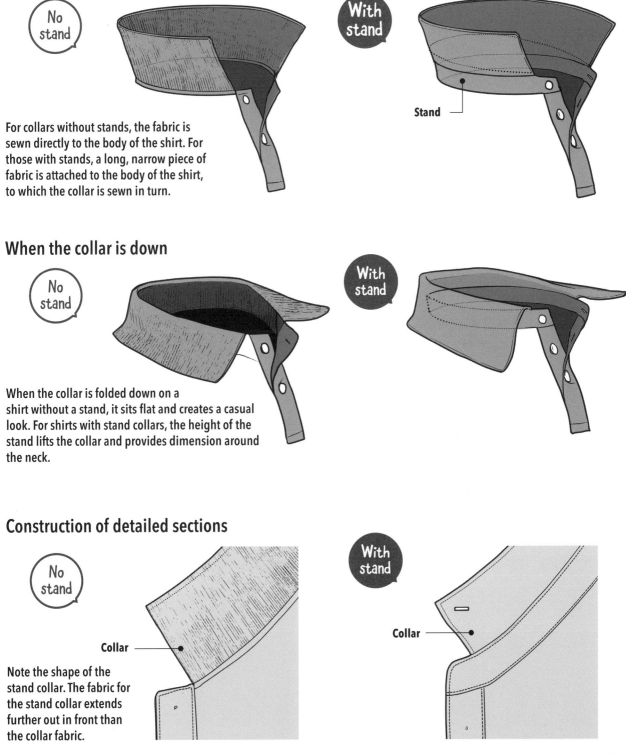

No stand

For collars without stands, the fabric is sewn directly to the body of the shirt. For those with stands, a long, narrow piece of fabric is attached to the body of the shirt, to which the collar is sewn in turn.

With stand

Stand

When the collar is down

No stand

With stand

When the collar is folded down on a shirt without a stand, it sits flat and creates a casual look. For shirts with stand collars, the height of the stand lifts the collar and provides dimension around the neck.

Construction of detailed sections

No stand

Collar

Note the shape of the stand collar. The fabric for the stand collar extends further out in front than the collar fabric.

With stand

Collar

Drawing a collared shirt using a T-shirt as a base

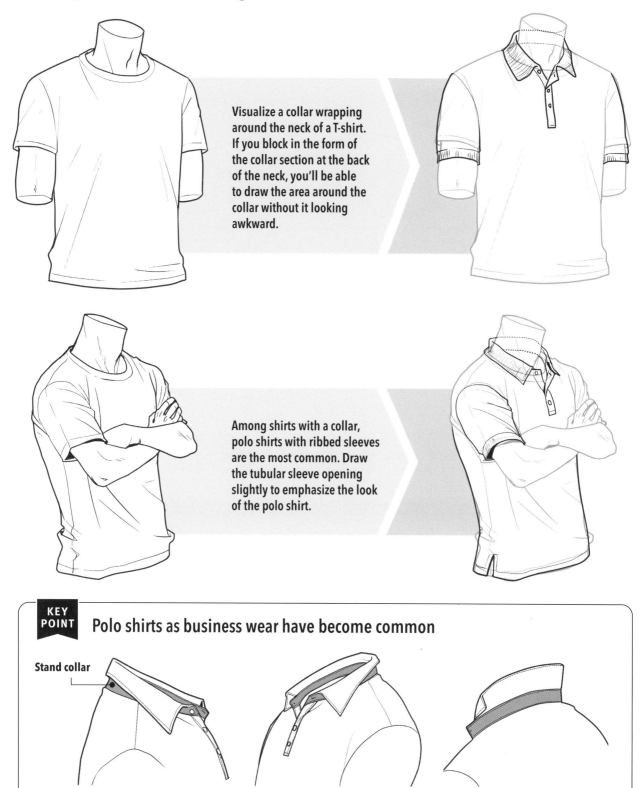

Visualize a collar wrapping around the neck of a T-shirt. If you block in the form of the collar section at the back of the neck, you'll be able to draw the area around the collar without it looking awkward.

Among shirts with a collar, polo shirts with ribbed sleeves are the most common. Draw the tubular sleeve opening slightly to emphasize the look of the polo shirt.

KEY POINT Polo shirts as business wear have become common

Stand collar

In recent years, office workers wearing polo shirts has increased. Most of them have a stand collar for a slightly more formal look.

Various collars

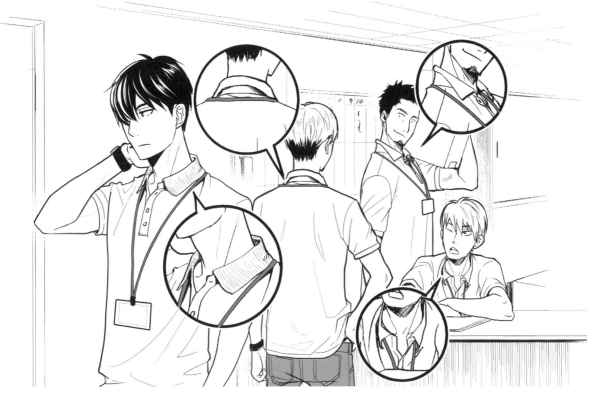

Apart from drawing collars to match characters' poses and angles, use them to match and express their personalities. Leaving a collar wide open or popping a collar can capture and suggest a character's inner qualities.

Other Shirts

Here, we take a look at long-sleeved shirts and sweatshirts. As the fabric gets thicker and more prevalent, the additional lines that follow the silhouette get larger and looser.

Long-sleeved shirts

Many of these items are made from relatively thin fabrics, meaning that the character's physique can easily be seen. Drawing in the creases that form in the sleeves and hem creates a more realistic look.

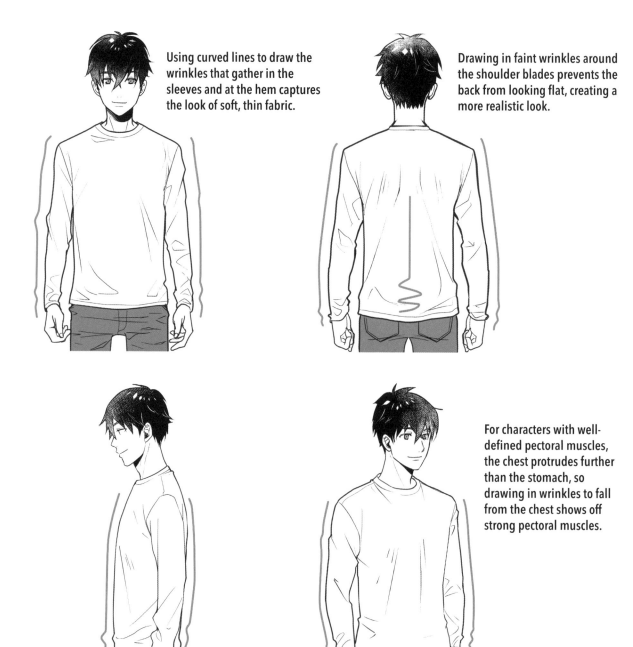

Using curved lines to draw the wrinkles that gather in the sleeves and at the hem captures the look of soft, thin fabric.

Drawing in faint wrinkles around the shoulder blades prevents the back from looking flat, creating a more realistic look.

For characters with well-defined pectoral muscles, the chest protrudes further than the stomach, so drawing in wrinkles to fall from the chest shows off strong pectoral muscles.

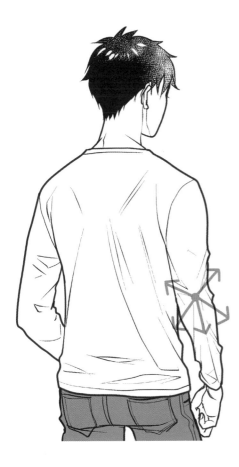

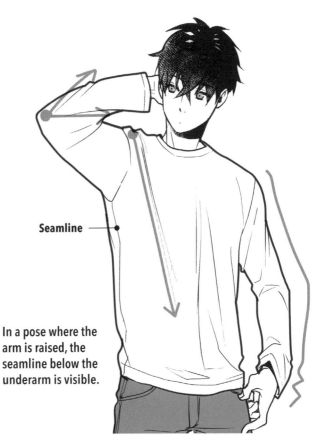

A pose with the hands in the back pockets. Pulling back the shoulders brings the shoulder blades together, with the elbows forming the points where the wrinkles start.

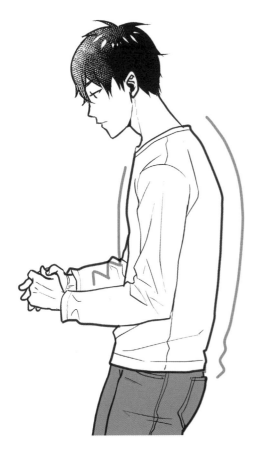

Seamline

In a pose where the arm is raised, the seamline below the underarm is visible.

Sweatshirts

When designing sweatshirts, draw them to look loose and with few wrinkles, to distinguish them from lighter, long-sleeved shirts.

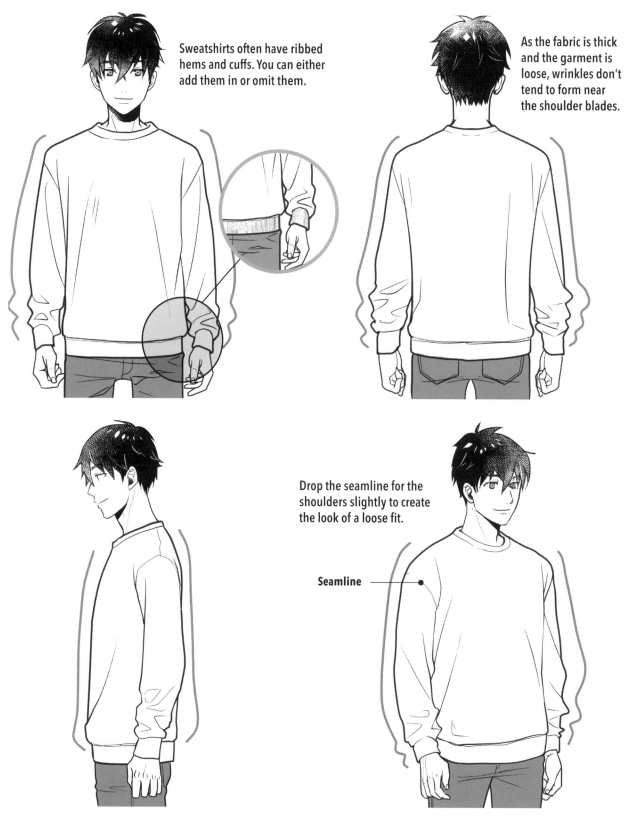

Sweatshirts often have ribbed hems and cuffs. You can either add them in or omit them.

As the fabric is thick and the garment is loose, wrinkles don't tend to form near the shoulder blades.

Drop the seamline for the shoulders slightly to create the look of a loose fit.

Seamline

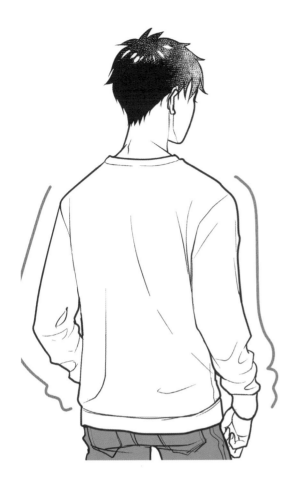

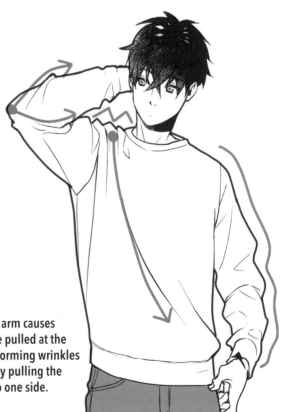

A pose with the hands in the back pockets. The fabric at the back gathers and forms wrinkles.

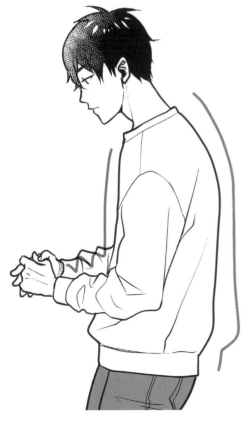

Raising an arm causes fabric to be pulled at the shoulder, forming wrinkles and slightly pulling the neckline to one side.

Sweatshirts (loose silhouettes)

A roomy pullover creates the appearance of a broader body and strongly conveys a relaxed impression. Drawing the shoulder seams lower down further emphasizes the loose, oversized fit.

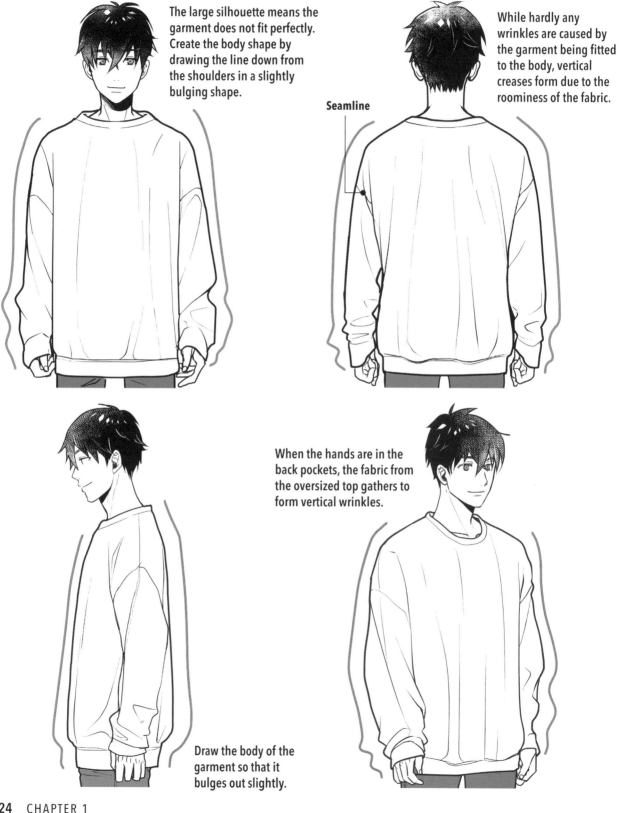

The large silhouette means the garment does not fit perfectly. Create the body shape by drawing the line down from the shoulders in a slightly bulging shape.

While hardly any wrinkles are caused by the garment being fitted to the body, vertical creases form due to the roominess of the fabric.

Seamline

When the hands are in the back pockets, the fabric from the oversized top gathers to form vertical wrinkles.

Draw the body of the garment so that it bulges out slightly.

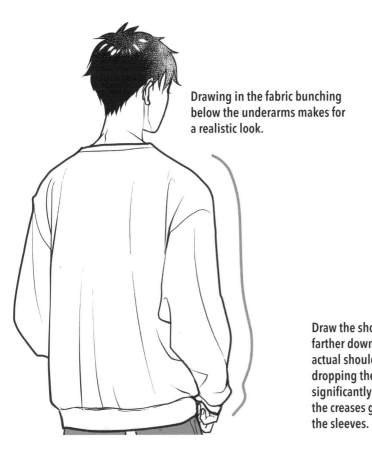

Drawing in the fabric bunching below the underarms makes for a realistic look.

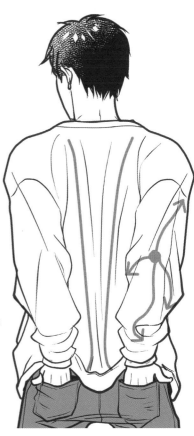

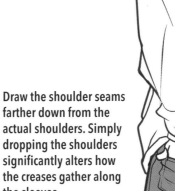

Draw the shoulder seams farther down from the actual shoulders. Simply dropping the shoulders significantly alters how the creases gather along the sleeves.

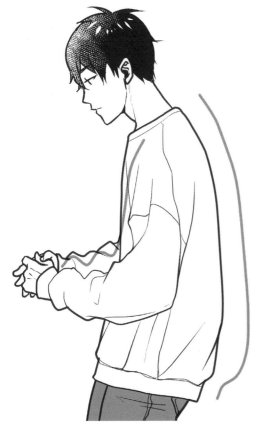

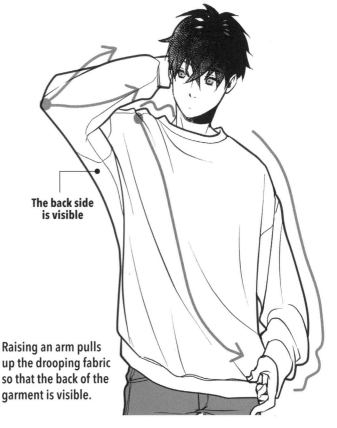

The back side is visible

Raising an arm pulls up the drooping fabric so that the back of the garment is visible.

Parkas & Hoodies

The trick to drawing a hoodie or a hooded parka is to capture the different shapes of the hood depending on the styling and the details of the scene or scenario.

Capturing the shape of the hood

⊘ **Basic shape** Regular hoods are made by sewing two pieces of fabric together. If you're having trouble replicating the shape, visualize the sewn-together fabric opening outward as you draw. Here, we've made it easier to understand the shape of the fabric by adding mesh-like guide lines (in grid form) to the insides of the hoods.

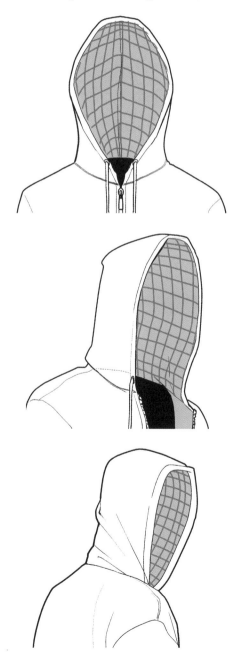
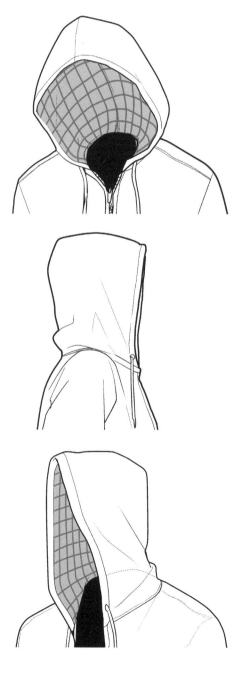

⊙ Hoods & heads

The blocking-in technique is especially helpful when it comes to drawing hooded characters in a variety of poses. Start by sketching in a box-like form that you'll then insert your character's head inside.

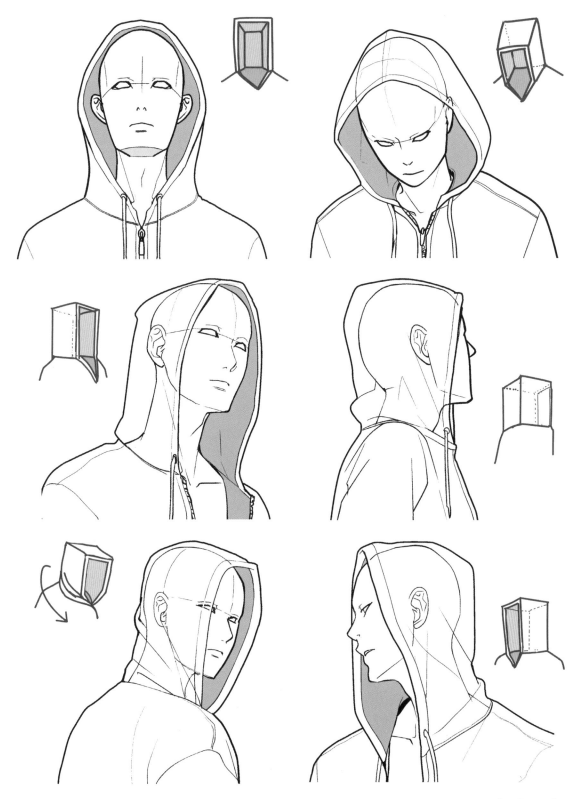

⊙ Changes in the hood's shape

The most difficult thing about drawing a hood is the way it changes shape when it's put on or taken off. In order to grasp the changes in the fabric, let's take a look at these perspective drawings that depict the parts that can't be seen. You'll see that even when the hood is pulled back and off the head, it's not completely flattened.

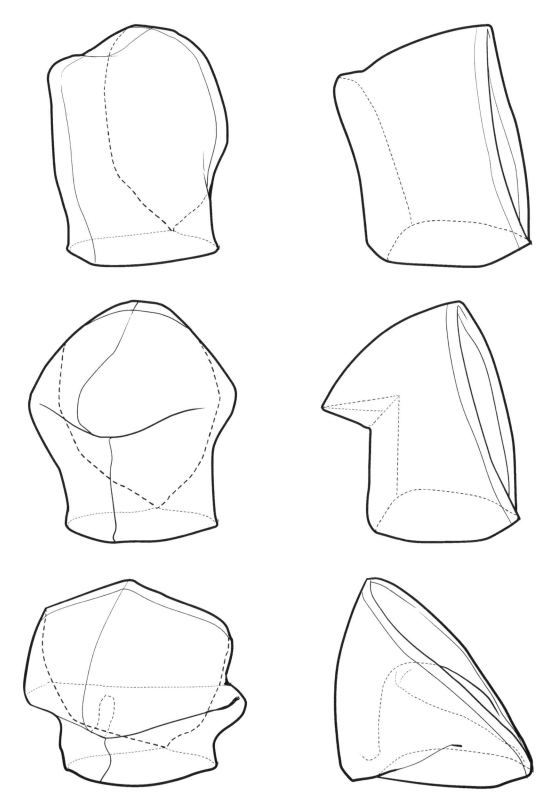

Draw the hood by imagining blocking in a box and fitting the hood over that box framework. This will prevent the hood from becoming flat and will convey a sense of the fabric's thickness.

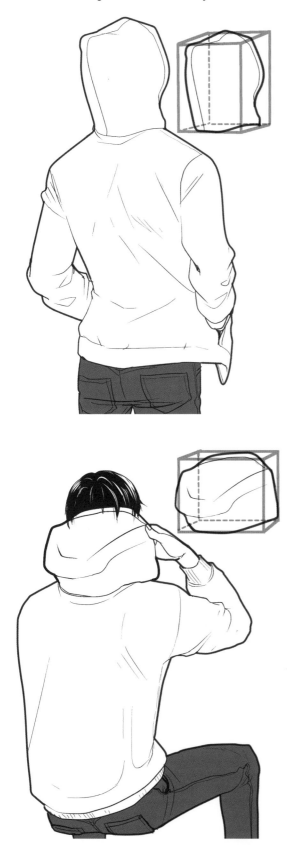

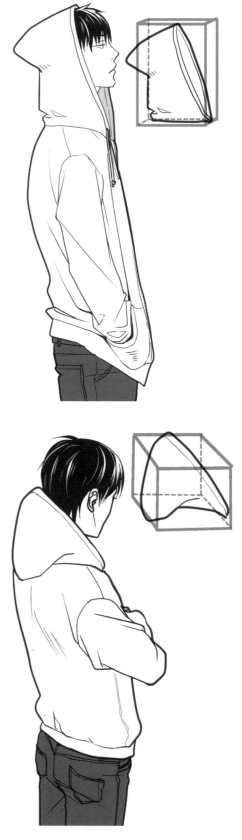

Types of hoodies

> **⊘ Pullover** Worn by being pulled over the head to emphasize that it's loose, everyday wear, the trick is to draw the shoulder seamlines slightly lower.

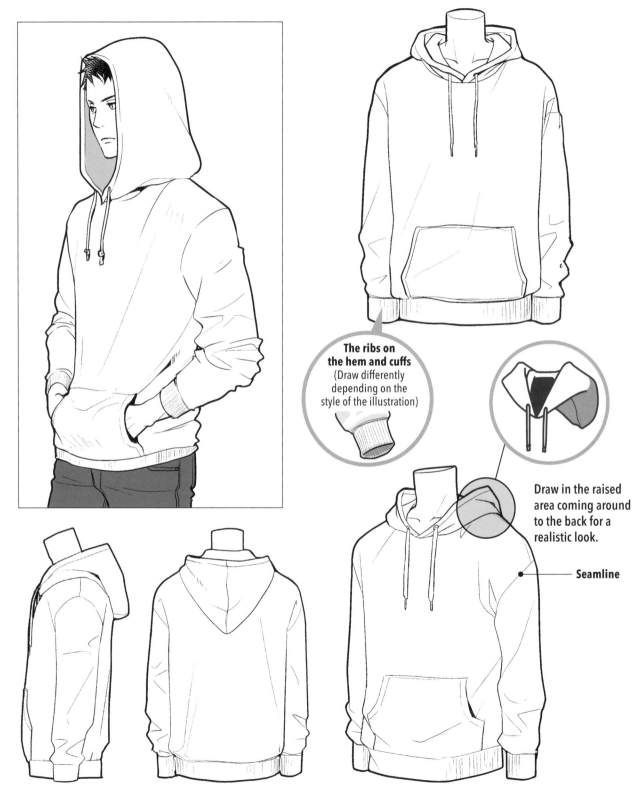

The ribs on the hem and cuffs
(Draw differently depending on the style of the illustration)

Draw in the raised area coming around to the back for a realistic look.

Seamline

⊙ Zip-front

Opening or closing the front allows for more variety in styling. Drawing it so that it's the right size, without lowering the shoulders, creates a contemporary, casual impression.

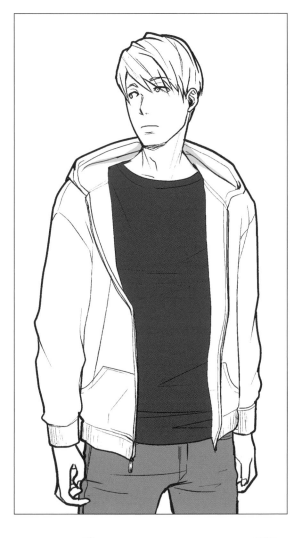

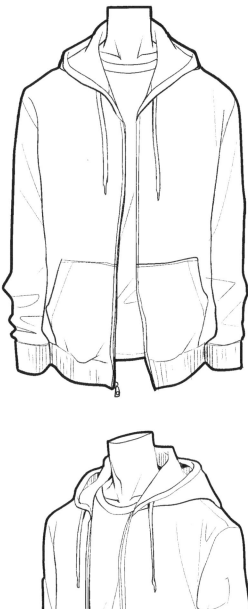

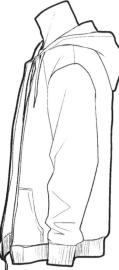

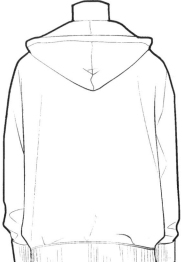

⊚ Funnel neck hoodie

The large neckline acts like a muffler to keep out the cold as well as being a design accent. The neckline doesn't open outward, so the hood at the back appears smaller.

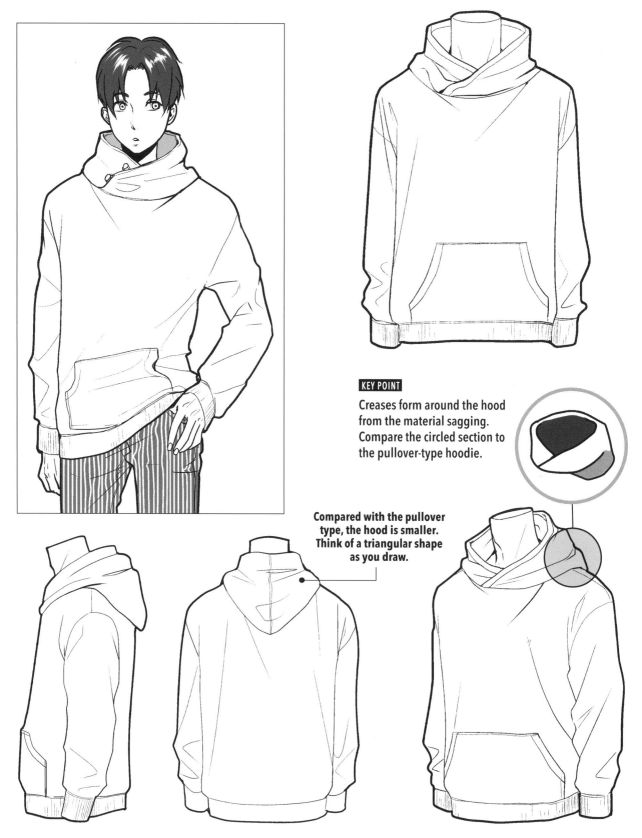

KEY POINT

Creases form around the hood from the material sagging. Compare the circled section to the pullover-type hoodie.

Compared with the pullover type, the hood is smaller. Think of a triangular shape as you draw.

⊙ Field jackets
Made for outdoor activities, it's water repellent and keeps out the cold. Most are made from thicker material than normal parkas, so the way wrinkles form differs also.

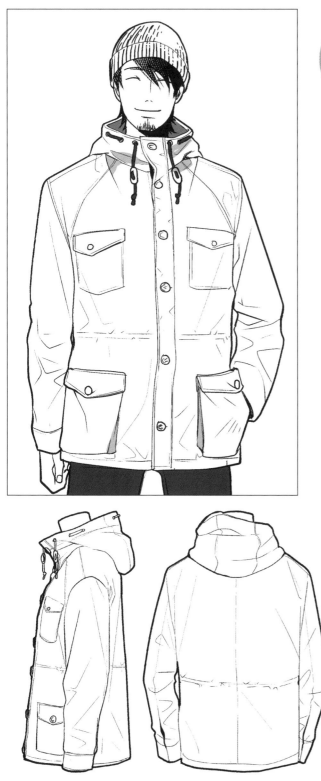

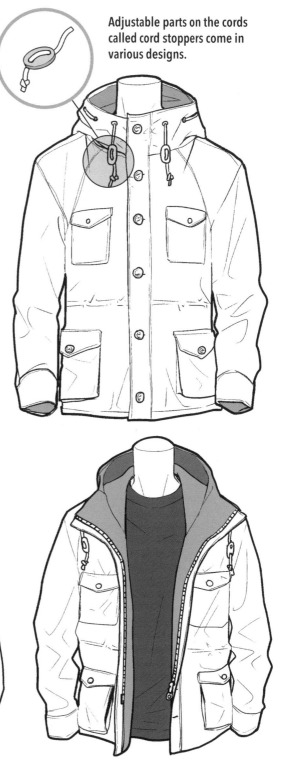

Adjustable parts on the cords called cord stoppers come in various designs.

If it's zipped or buttoned all the way to the top, the hood appears small.

This drawing is an example of where both sides of the zipper are attached to the lining fabric. On some jackets, one side of the zipper is attached to the outer fabric.

Different necklines

Let's take a look at the different neckline shapes formed by zip-up hoodies with high necks.

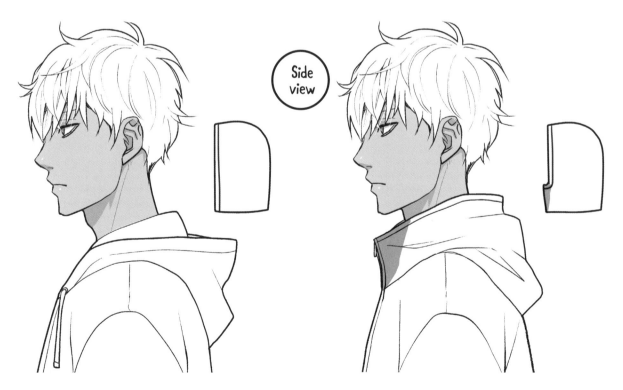

Front

For regular styles, even if zipped all the way up, the area around the neck is clearly visible.

For high-necked types, if zipped all the way, the neck is somewhat concealed.

Side view

On regular versions, the line from the chest to the hood is smooth and curved.

On high-necked types, a corner appears to protrude from beneath the chin.

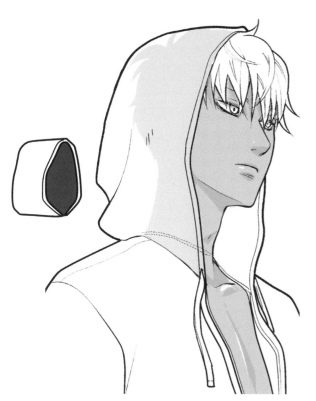

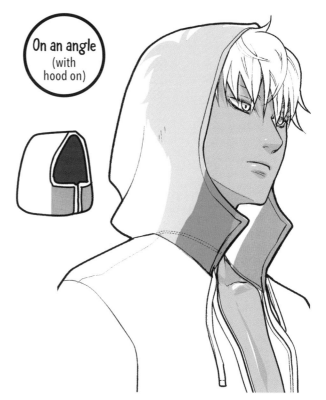

On an angle (with hood on)

For regular styles, the back of the neck is hidden but the front is visible.

For high-necked types, the collar section conceals the neck.

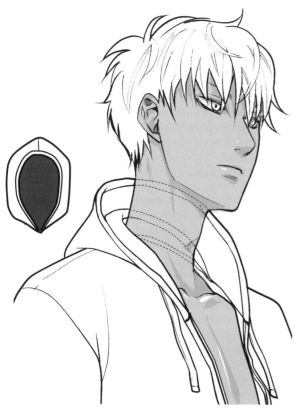

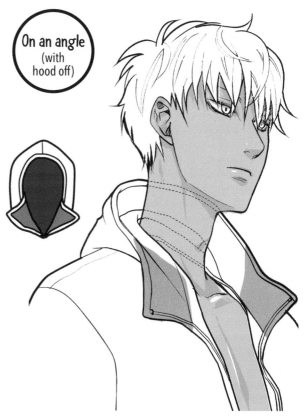

On an angle (with hood off)

Smooth lines cover the area around the neck and down the chest.

The edges open out to each side on high-necked types.

Differences in hood shape

Let's examine hoods when they're down, viewing them from various angles. At a glance they all appear similarly crumpled, but differences arise in shape between regular hoodies and high-necked types.

Regular

High-necked

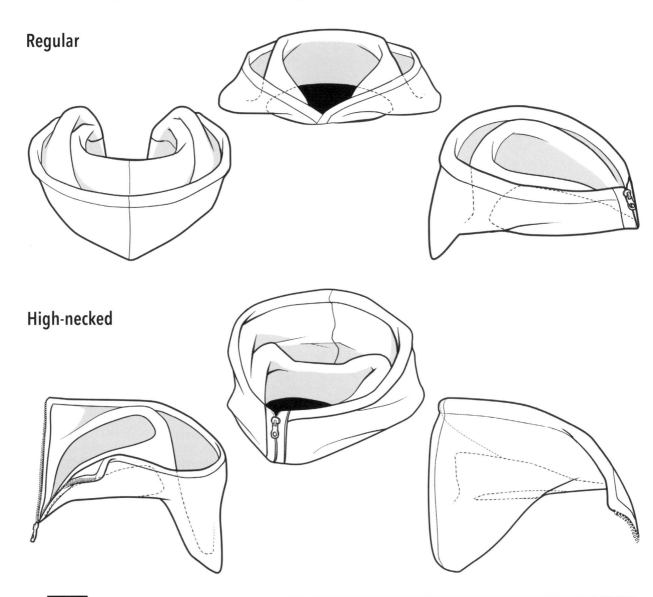

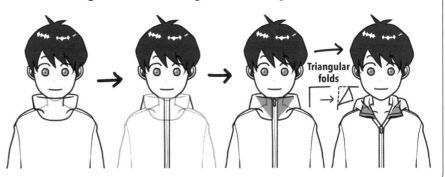

KEY POINT

If you're stuck when drawing the front of high-necked styles

If you're having trouble drawing the front of high-necked types, try blocking in a cut-and-sewn top instead. Add a zipper to the front, visualizing the collar flipped out to form triangles.

Triangular folds

An example of starting with the hood. Visualizing a box in order to capture the shape of the hood in solid form makes it easier to match it to the direction and angle the character is facing.

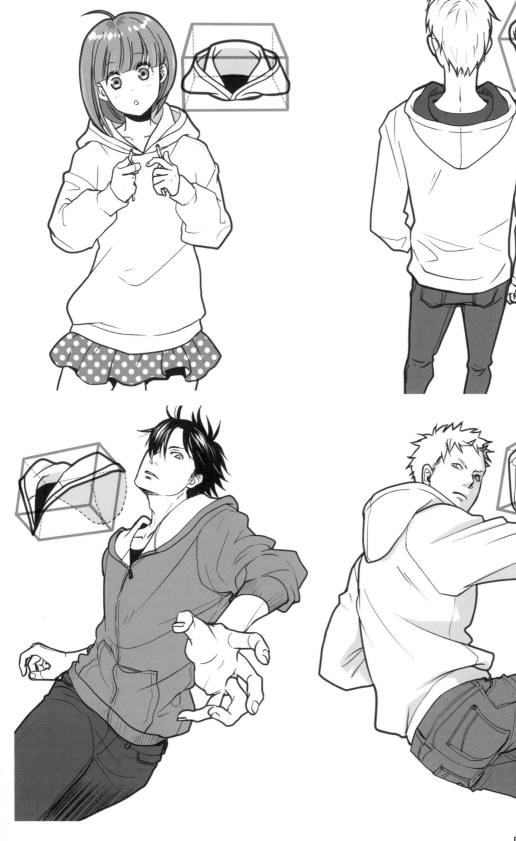

Pants

There are various styles of pants. Learning the basics of fabric, shape and fit allows you to find the perfect fit for your characters.

Basic fabrics

Made of cotton, polyester or jersey, with wrinkles forming in different ways depending on the fabric, it's enough to master the three types below. Combining the fabric types with different shapes or fits allows various realistic looks and styles to be created.

⊙ **Thick fabric** Often used for jeans, denim is a hard, stiff material. Fine wrinkles do not tend to form in denim. Adding lines to show the thick fabric sewn together makes for a more authentic look.

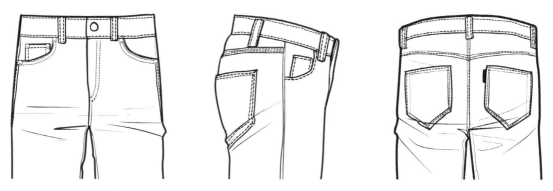

⊙ **Regular fabric** The most standard type of cotton fabric. Drawing cotton pants in a slim fit makes for an elegant, casual look, while making them broader creates pants for work wear.

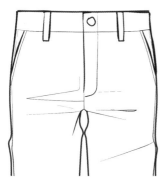
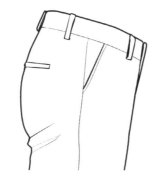
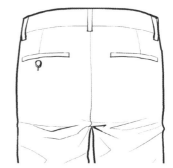

⊙ **Elastic waist** Commonly used for track pants or sweats, the fabric is soft and supple. Keep straight and horizontal creases to a minimum to express softness.

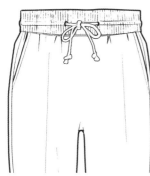
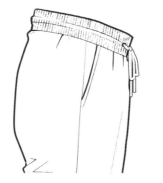
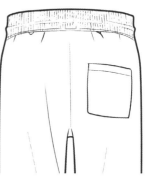

Basic shapes

There are many different names for the shape or fit of pants, making things complicated, but when drawing pants it's best to simplify the silhouettes to the four types shown here.

Straight

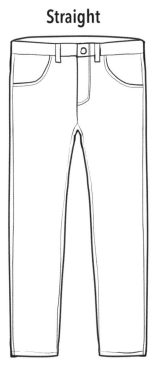

The silhouette is straight from the waist to the ends of the legs. These are style classics.

Slim

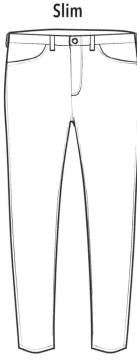

A silhouette that fits close to the legs. They create a smart, stylish impression.

Wide leg

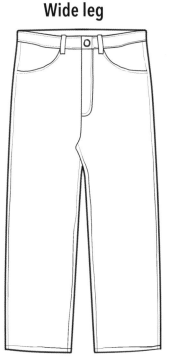

In contrast to the slim fit, this silhouette is roomy and doesn't cling to the legs, creating a relaxed feel.

Shorts

As they expose the legs, they strike the ultimate casual, summery note.

Variations

When you want to be more particular about an outfit or express personality, try using variations like the ones below.

Drop-crotch pants

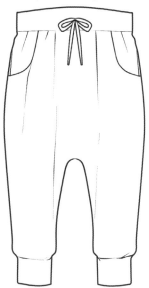

Pants with their roots in traditional folk costume are characterized by the crotch being significantly lower than for regular pants.

Cargo pants

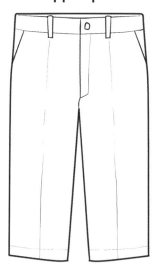

These pants are distinguished by their many pockets and casual flair.

Tapered pants

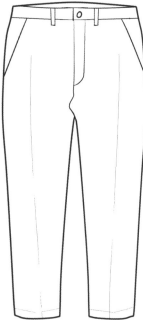

Pants that are slimmer (tapered) toward the hems, unlike slim pants, they don't cling to the thighs.

Cropped pants

Short pants that have been cropped at the hem. Compared with long pants, they make a casual impression.

Combined designs

Combining the fabrics from page 38 with the shapes from pages 39 and 40 allows you to create a range of pants for your characters.

(ex. 1) Supple fabric + shorts = sweat shorts

Ideal for characters' regular wear or casual styling. These work well with T-shirts and sandals.

 + =

(ex. 2) Wide-leg + tapered = peg-legged pants

Loose around the thighs, these pants taper at the legs. In an illustration, the volume around the waist and hips stands out.

 + 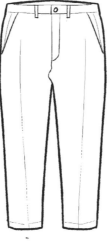 =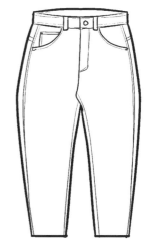

(ex. 3) Cropped + Cargo = below-knee cargo pants

The pockets of cargo pants are added to casual, cropped pants. This works for when you want to add an accent to unpretentious casual wear.

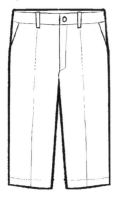 + 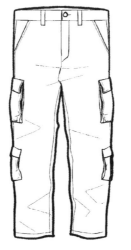 =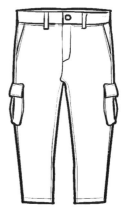

Tricks for expressing wrinkles in pants

⊙ How wrinkles form and how to draw them

In pants, the fabric forms cylindrical shapes, with excess fabric sagging in waves to create creases. It's easier to get the knack of drawing wrinkles in pants by blocking in the wave-like shapes on the outer edges before filling in the details on the insides.

Another drawing method is to create a diagram with a criss-crossed grid superimposed in order to draw in the details. Using the diamond-shaped sections as a base, add in collapsed diamond shapes at random to create a natural look.

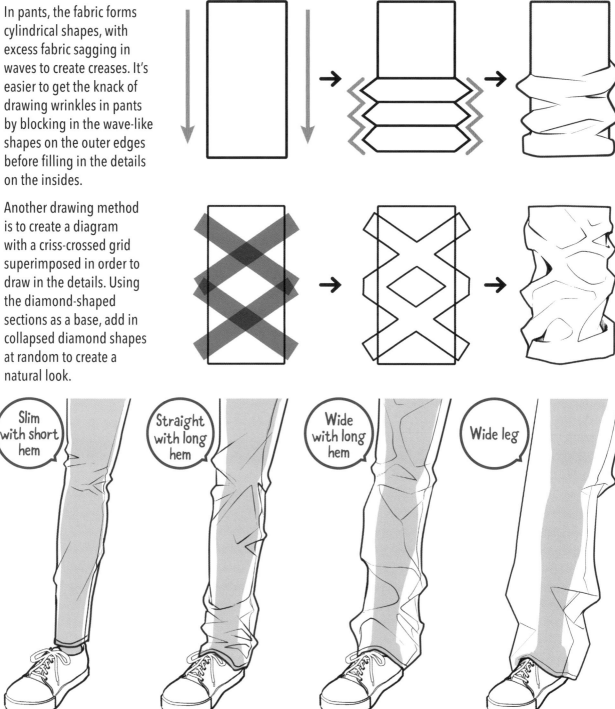

Slim with short hem

Straight with long hem

Wide with long hem

Wide leg

A view of the legs inside pants. As they cling to the legs, slim pants with short hems don't tend to crease. The wider and the longer the hems, the roomier the pants and the more likely wrinkles will form. In particular, wide-legged pants are less affected by the legs within, so there are fewer fine wrinkles while large bumps and creases form.

⊙ Differences in creases depending on fabric

Firm, springy material forms more rigid contours and large creases. Conversely, fine wrinkles appear in thin fabric. Bumps don't tend to form in thick fabric, with creases also evening out.

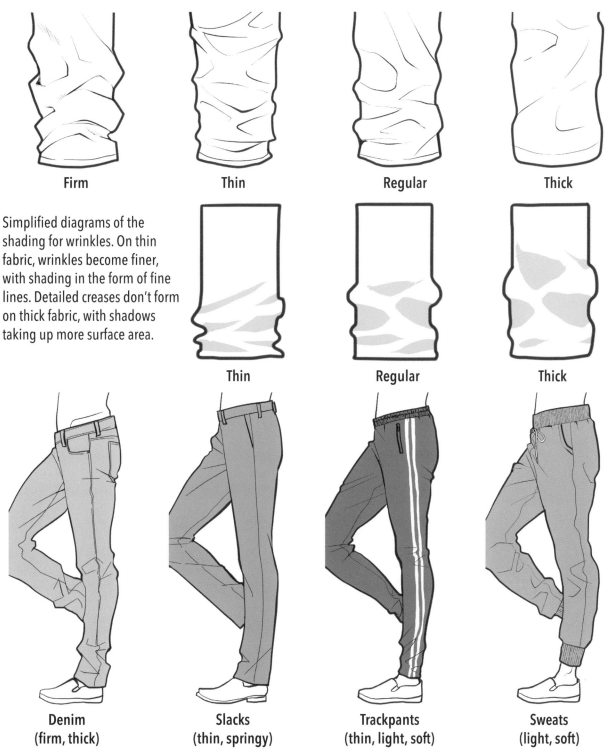

Firm Thin Regular Thick

Simplified diagrams of the shading for wrinkles. On thin fabric, wrinkles become finer, with shading in the form of fine lines. Detailed creases don't form on thick fabric, with shadows taking up more surface area.

Thin Regular Thick

Denim
(firm, thick)

Slacks
(thin, springy)

Trackpants
(thin, light, soft)

Sweats
(light, soft)

A diagram showing pants made of different fabrics. Even with the character in the same pose, it's possible to see that the fabrics are different. By drawing not just the small details but also the wrinkles differently, you can create the look of several different styles of pants.

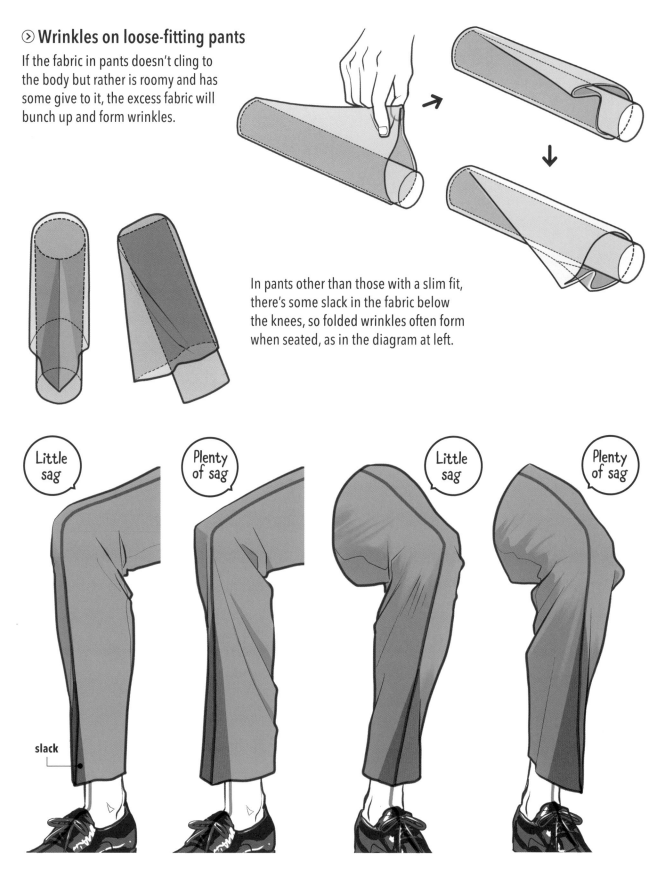

⊙ Wrinkles on loose-fitting pants

If the fabric in pants doesn't cling to the body but rather is roomy and has some give to it, the excess fabric will bunch up and form wrinkles.

In pants other than those with a slim fit, there's some slack in the fabric below the knees, so folded wrinkles often form when seated, as in the diagram at left.

Little sag

Plenty of sag

Little sag

Plenty of sag

slack

Examples of pant legs when characters are seated. The fabric slackens at the front of the shin, creating wrinkles. Use the center line of the legs as a guide for blocking in the shape.

⊙ Creases around the waist

Wrinkles often form around the waist, when sitting, walking or bending. Soft fabric changes shape more extensively and forms larger wrinkles.

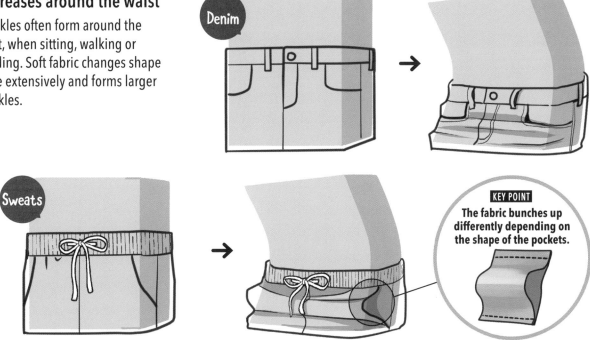

KEY POINT

The fabric bunches up differently depending on the shape of the pockets.

For fitted pants, convey the close fit by adding few creases, except for around the joints. For looser pants, create bold sagging and flowing wrinkles to express the play of the fabric and create a realistic look.

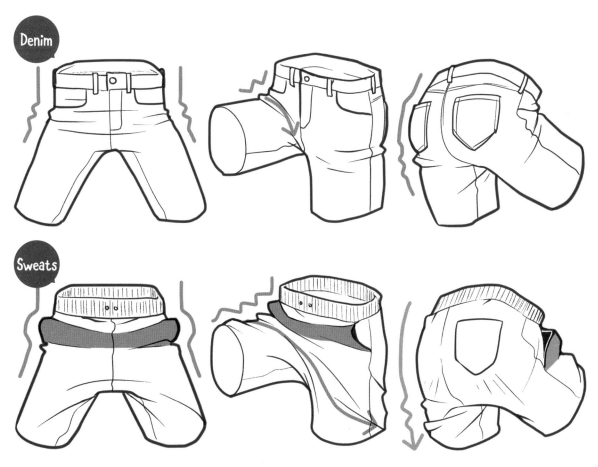

Drawing denim

Originally made for outdoor laborers, denim jeans are now standard wear. They're certainly a staple of manga and anime, so master how to render a range of jeans for that authentic look.

⊙ Grasp the characteristics of denim

As denim was originally for laborers, it's made to be sturdy. Drawing in the stitching and the five pockets makes for an authentic look.

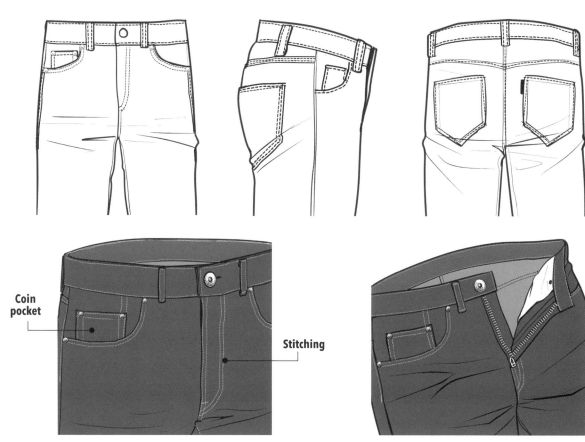

Coin pocket

Stitching

There is stitching on the fly (front section) and pockets, and there's often a small coin pocket inside the front right pocket.

An open zipper: the pocket lining is visible.

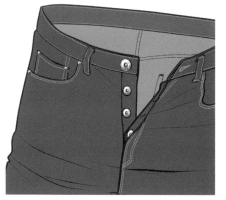

The back pockets are also stitched firmly in place. The stitching on the pockets has a distinctive design depending on the brand.

Button fly is a detail often seen on vintage jeans or retro styles.

⊙ Differentiating from slim to wide

As slim pants cling to the legs, creases don't tend to form in the thighs or around the hems. In contrast, on wide pants, there's slack around the thighs and hems, so creases tend to form in those areas. Drawing a firm, crinkled crease makes for a more denim-like look.

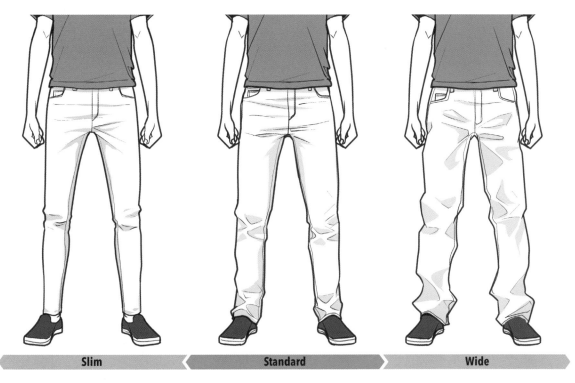

| Slim | Standard | Wide |

On slim pants, there are few wrinkles apart from at the backs of the knees. Wide pants are roomy around the waist and hips, so wrinkles form around the buttocks.

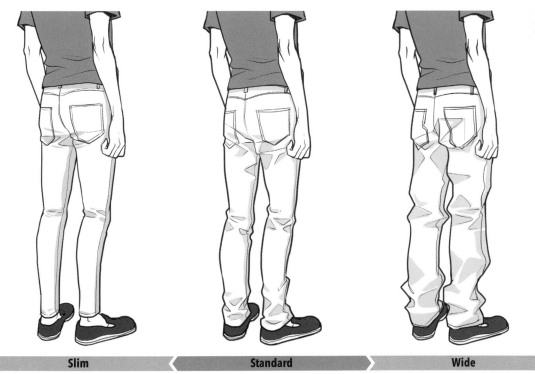

| Slim | Standard | Wide |

Drawing sweatpants & trackpants

Sweats and trackpants are familiar as sportswear and loungewear. Both are made from soft, knitted fabric.

⊙ Grasping the characteristics of fabric

Sweats and trackpants are made from different fabric, but when drawing them, they're nearly indistinguishable. Both are made from soft material so don't tend to form horizontal creases, with the fabric falling straight to the ground.

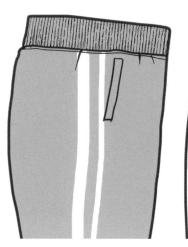
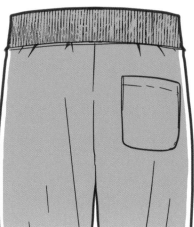

⊙ Types of waistbands

Ties that adjust at the waistline are a common feature. There are various types of waistbands, such as ones made from knitted ribbing with a cord running through it or gathered bands.

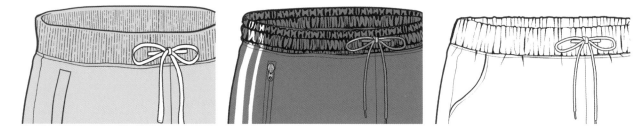

⊙ Types of hems

Items for loungewear often have loose-fitting hems. Those designed for sports and athletics may have hems made from knitted ribbing.

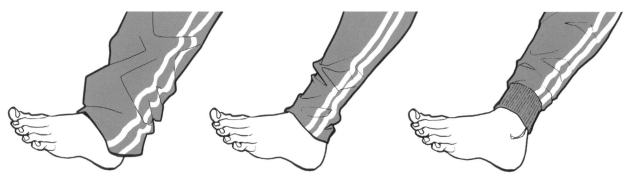

⊙ Loose, straight fit

The fabric is soft, so rather than creases forming around the thighs, visualize the fabric draping downward. If the pants are long, creases form around the feet. Leaving the area around the buttocks free of horizontal creases emphasizes the sense of looseness.

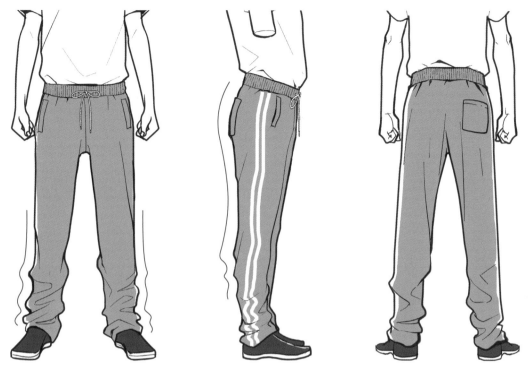

⊙ Slim jogging pants

Wrinkles form differently in pants such as jogging pants with ribbed cuffs. Block in the shape so that wrinkles gather around the joints. Adding horizontal wrinkles around the buttocks emphasizes the slim fit.

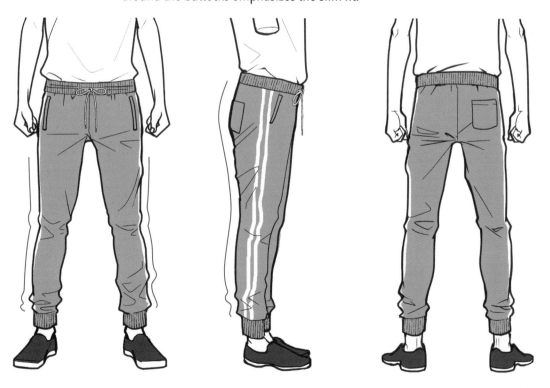

Drawing wide-legged pants

Pants with wide legs can be used for rough, workwear-like styling as well as for elegant, casual outfits. Their look changes significantly depending on the material, so it's important to differentiate between fabrics in illustrations.

> ## Cargo pants
Super-casual cargo pants are conveyed by creating a boldly jagged silhouette to express firm, resilient fabric. As they don't cling around the buttocks, creasing is minimal.

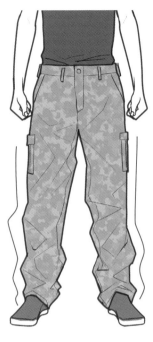

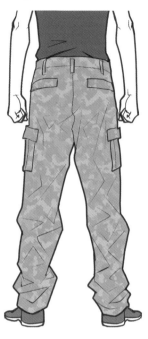

> ## Cropped wide-legged pants
These are the shortest among wide-legged pants. Types made from thin fabrics such as polyester or rayon are popular as casual items. This type of fabric doesn't wrinkle much, so don't draw in too many creases.

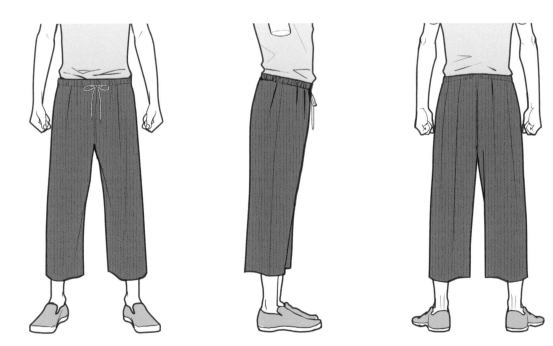

Drawing other pants

⊙ Drop-crotch pants

The crotch is positioned significantly lower than it would be on standard pants. There's plenty of fabric around the hips, so draw in a lot of vertical wrinkles.

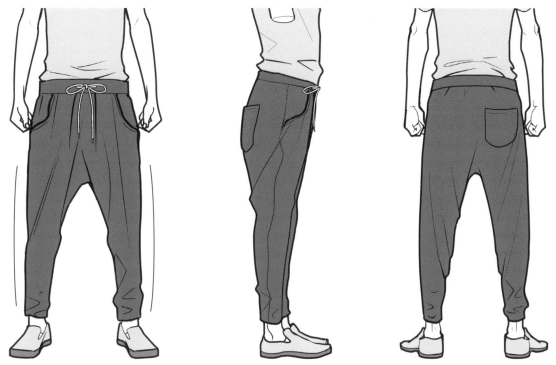

⊙ Short pants (cargo shorts)

There are a lot of details using straight lines, such as the pockets, but if you use straight lines around the buttocks, the shorts will appear flat. The trick when drawing these is to keep the roundness of the buttock area in mind when adding the details.

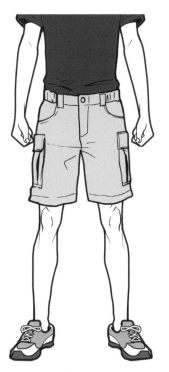
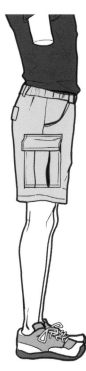
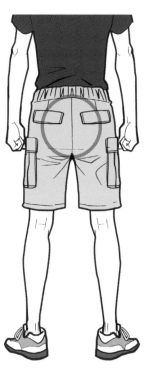

Drawing pants for different bodies

⊙ Grasping differences around the waist

Differences in physique are apparent when characters are in fitted pants. For some characters, block in a rounder shape around the hips for a fuller look.

For some characters, blocking in a box helps create the desired effect. For others, visualize a peach to flesh out the hip area.

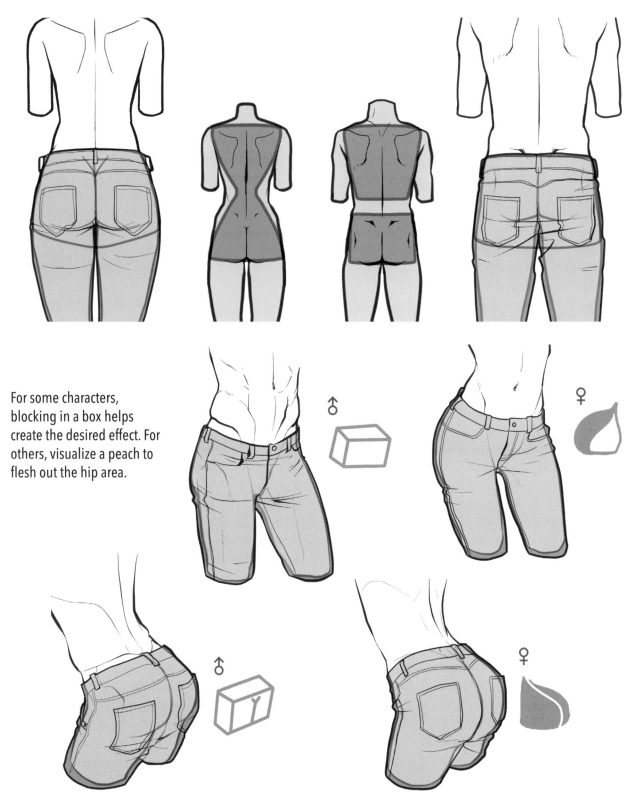

⊙ Various looks and poses

For slim-legged characters, focus on the smooth curves of the waist, the roundness of the hips and the contours of the calves. The trick to accentuating the legs is to convey a sense of rhythm in curved lines and to create a striking pose.

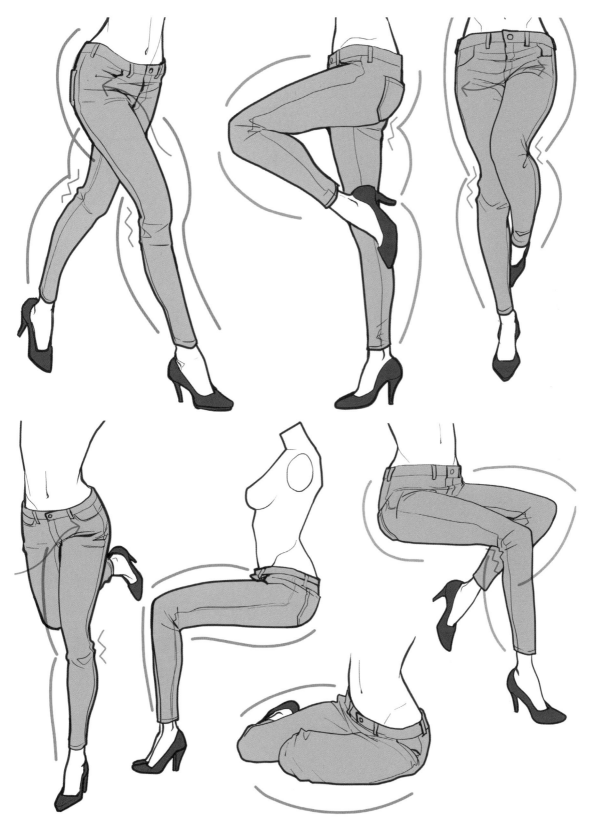

Movement and creasing

⊙ Fitted pants (skinny jeans)

If you add in more creases than are necessary, the pants will appear crumpled, so the trick is to add in just a few key areas such as the joints.

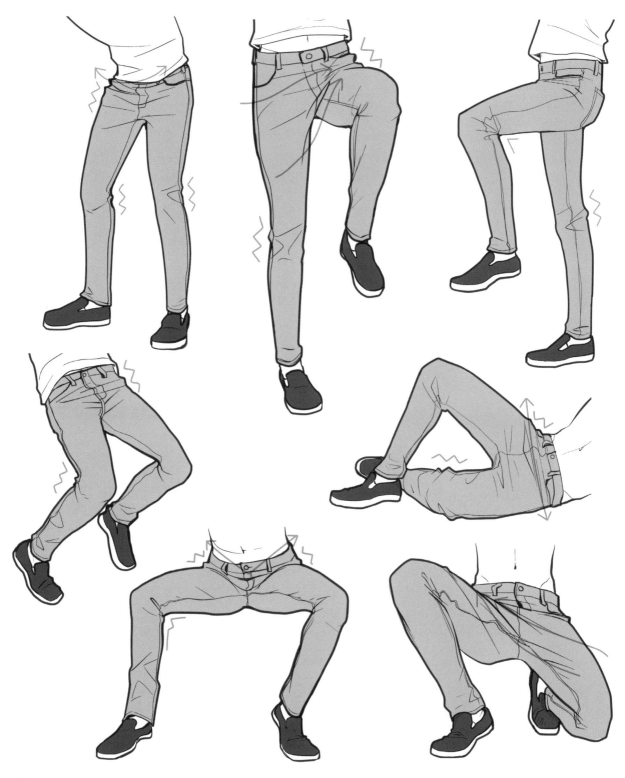

⊙ Roomy pants

Wrinkles form more easily than in fitted pants, but in this case, too, the trick is not to draw in more than are necessary. The greater the play of the fabric, the bolder the flow of wrinkles to suggest a sense of roominess.

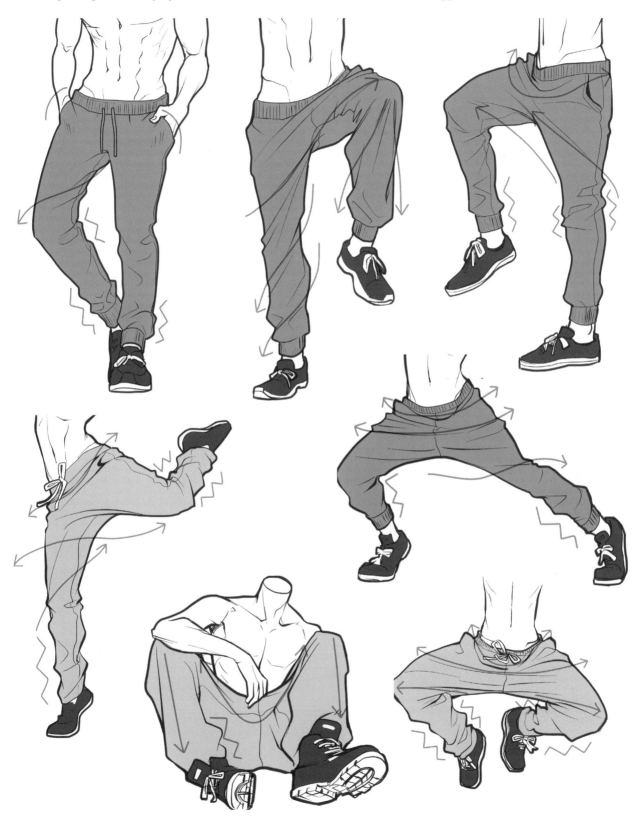

Skirts

Skirts are an essential item in classic and contemporary fashion. It's easier to add unique details such as gathers, flares and pleats if you know how skirts are formed and constructed.

Basic skirt shapes

There are all kinds of skirt designs, but it would be difficult to learn them all. For the purposes of manga, anime and cosplay, start by learning these four types.

Fitted skirt

This type of skirt is fitted to the body from the hips down the legs. It's good for a mature character or one wanting to accentuate sex appeal.

Flared skirt

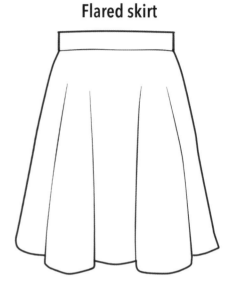

The hem flares out and the fabric ripples. It makes a neat, clean impression.

Pleated skirt

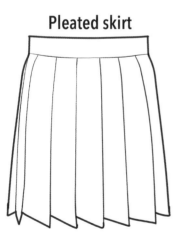

The pleated skirt is a familiar element in school uniforms, the construction creating flow and motion.

Tiered skirt

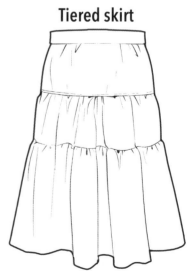

The fabric is sewn together to form tiers. Depending on the design, they bring a sense of casual flow.

Other variations

Here are some examples of skirts showing the basic version and skirts with slightly different construction and silhouettes. Take a look at each one to see how different construction techniques lead to differences in appearance.

Straight skirt

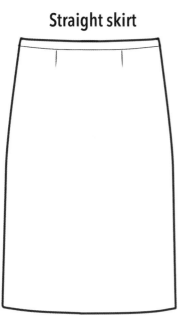

Unlike the tight skirt, this type doesn't cling to the body and the hemline doesn't taper in.

Tucked flare • Gathered flare

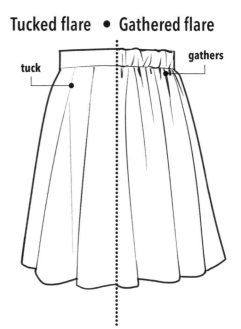

Flared skirts where the fabric is folded down and sewn in place (creating tucks) differ from regular flared skirts as clear tuck lines appear around the waist and hips. For skirts that have fabric drawn up tightly around the waist (gathers), the waist section is depicted differently.

Box pleats

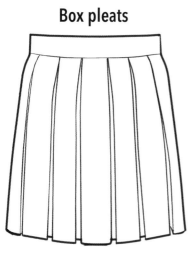

At a glance, these pleats look the same as those on the page at left, but if you look carefully, the form of the pleats is different, protruding in the shape of a box.

Other tiered skirts

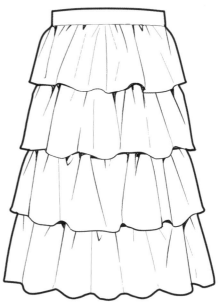

A skirt made from multiple layers of frills, the fabric is sewn in successive tiers.

Wrinkles in skirts

⊙ Thinking in terms of a large piece of fabric

Except for tight skirts, wrinkles tend to form in areas that don't cling to the body. Substituting a large piece of fabric for a skirt makes it easier to visualize what kind of wrinkles are formed in particular poses.

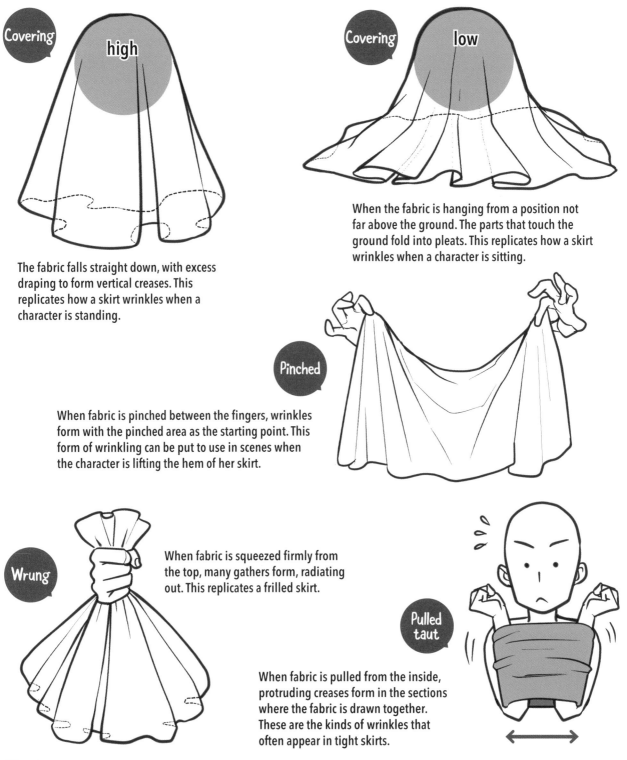

Covering high

The fabric falls straight down, with excess draping to form vertical creases. This replicates how a skirt wrinkles when a character is standing.

Covering low

When the fabric is hanging from a position not far above the ground. The parts that touch the ground fold into pleats. This replicates how a skirt wrinkles when a character is sitting.

Pinched

When fabric is pinched between the fingers, wrinkles form with the pinched area as the starting point. This form of wrinkling can be put to use in scenes when the character is lifting the hem of her skirt.

Wrung

When fabric is squeezed firmly from the top, many gathers form, radiating out. This replicates a frilled skirt.

Pulled taut

When fabric is pulled from the inside, protruding creases form in the sections where the fabric is drawn together. These are the kinds of wrinkles that often appear in tight skirts.

⊙ Understanding angles

A skirt viewed from various angles. Wrinkles radiate outward from the waist, with fabric pooling increasingly toward the hem.

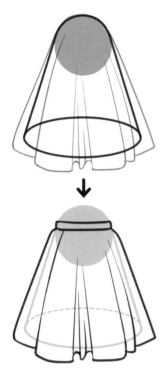

⊙ Thinking in simplified forms

If you're having trouble drawing the skirt, try thinking of it in a simplified way. Start by drawing a simplified shape, then add in wrinkles and pleats.

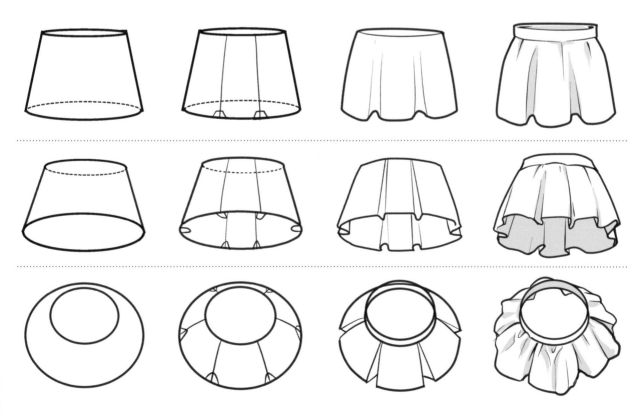

⊙ Getting a grasp of the fabric flow

In cases where the skirt sways due to a breeze or movement, draw a simplified version first to capture the flow of the fabric. The direction of the pleats follows the flow of the fabric, but adding in variation in some places makes for a more natural expression.

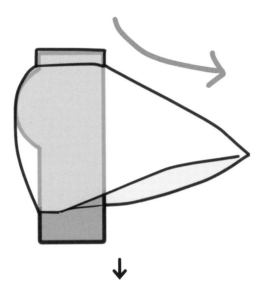

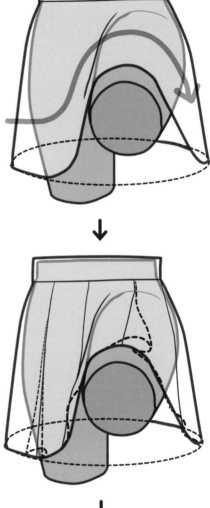

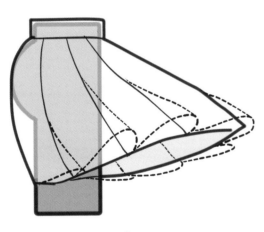

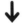

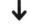

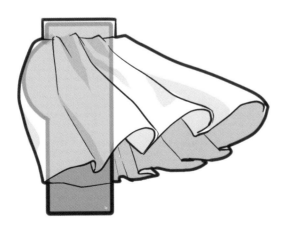

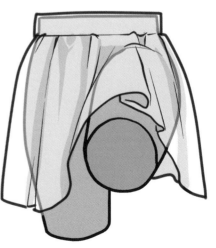

The differences between gathers, frills, flares and draping

Creases and pleats in skirts add realism and flow. Let's compare how these features form and the differences in how they're rendered.

⊙ Gathers and frills

Parts of the fabric where fine pleats form when a cord is passed through the fabric and pulled are known as gathers (the sewing technique is called "gathering"). The fabric below the gathers forms undulating pleats called frills.

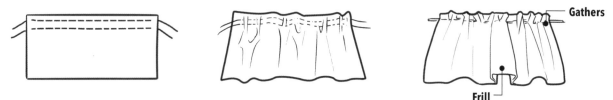

⊙ Flares and draping

A skirt with a flared hem that moves in waves is called a flared skirt. The flared parts of the skirt are referred to as draping. Depending on the volume in the skirt, the draping can be modest or puffy and voluminous.

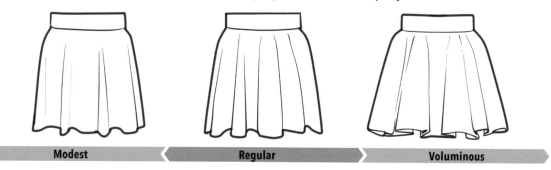

Modest ◁ Regular ◁ Voluminous

⊙ The difference between gathers and no gathers

If there are no gathers in a skirt, the start of the drape is gentle and neat. If there are gathers, creases and pleats form near the waist section.

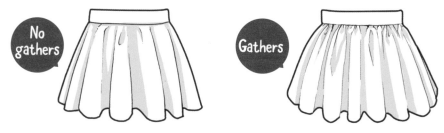

⊙ Drawing tricks

When drawing the convex and concave parts of pleats, consider their depth and align the depth of larger pleats for a natural effect.

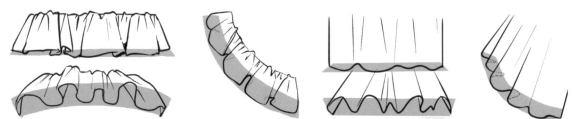

Skirts in motion

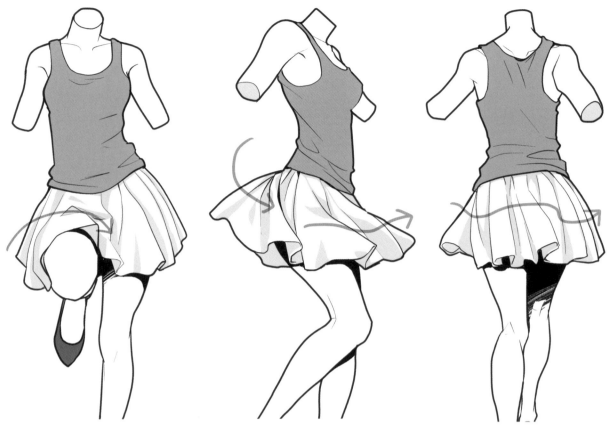

When the character moves, the skirt hem boldly sways and billows. Altering the shape of the skirt to align with movements such as walking or the fabric riding up on a raised leg gives the illustration a sense of dynamism.

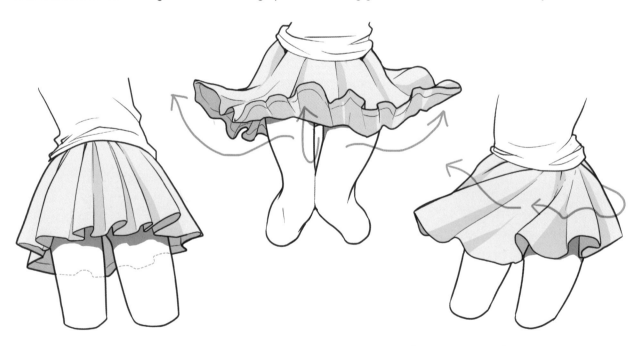

If the character bends down suddenly, the hem of the skirt will rise up and fold back on itself. Sudden turns create twisting motion in the skirt. The way the skirt is depicted can be used to express how the character has moved.

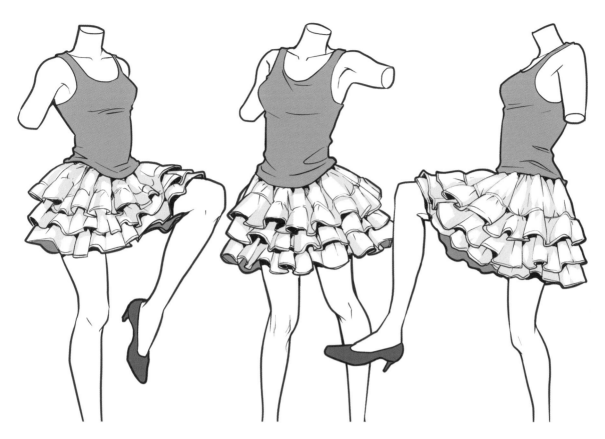

This example shows a skirt with a lot of frills. In a movement where the leg is raised, the fabric fans out and the undulations become less pronounced.

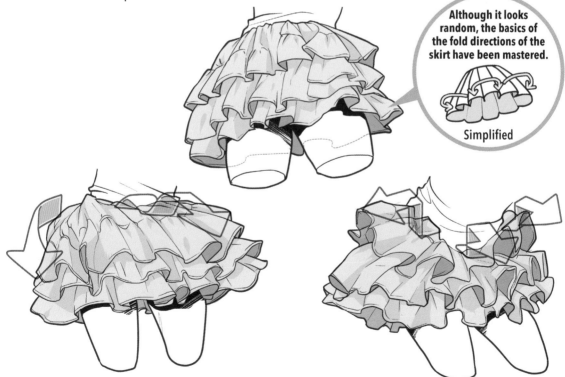

Although it looks random, the basics of the fold directions of the skirt have been mastered.

Simplified

It may seem difficult to draw a skirt with lots of frills, but if you confirm the direction of the frills in a simplified drawing, it's easier to grasp their form.

An example of a long skirt. Compared with a miniskirt, the pleats fall in a gentle flow. Bending the knees or pinching the material between the fingers creates the starting point for a new directional flow to the fabric.

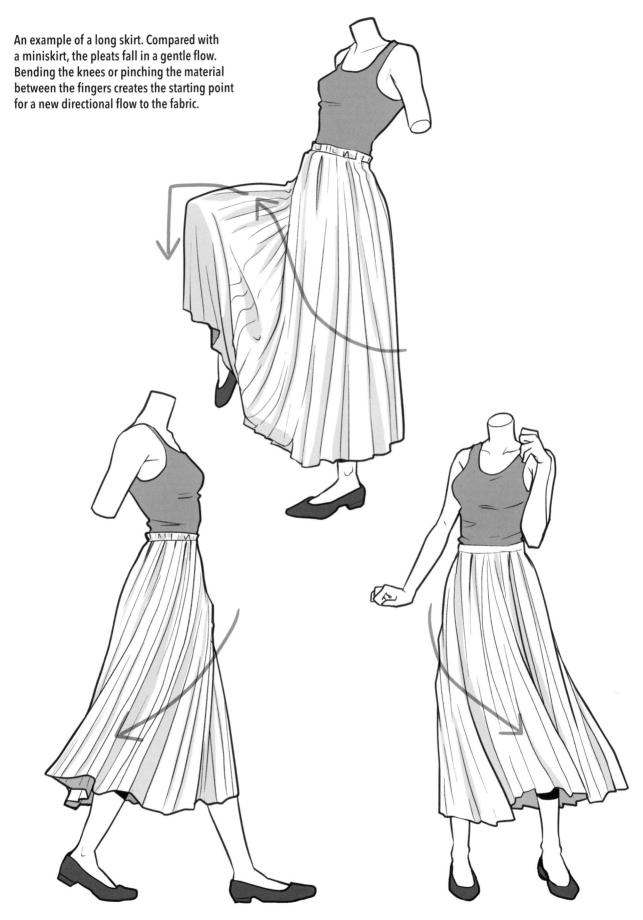

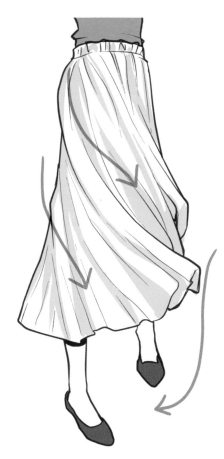

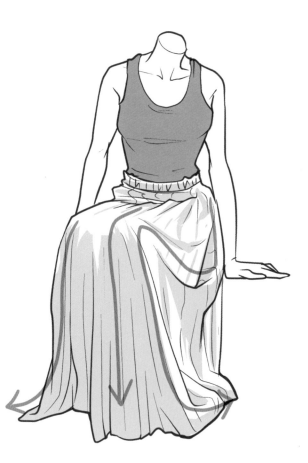

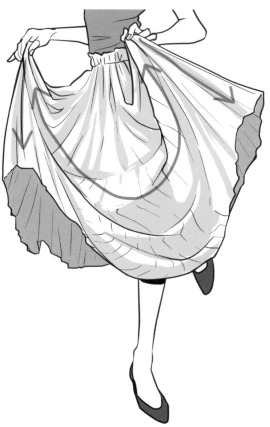

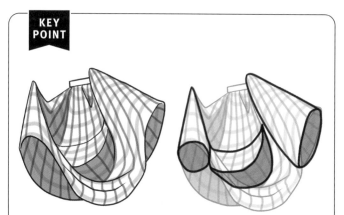

Replace the pattern with a grid to capture a sense of dimension

In the picture on the left, a pinching motion is added to the skirt, so it may seem like the flow of the fabric is more complicated. In cases like this, try using a check or grid pattern to get a better understanding of the flow of the skirt. It's also helpful to try to create the inner space by using blocks to get a sense of the dimensions.

Build on the skirt to draw a dress

Once you can draw a skirt, you'll be able to use the same steps to draw a dress. Use the arrows as a guide to master how the fabric changes depending on the various poses.

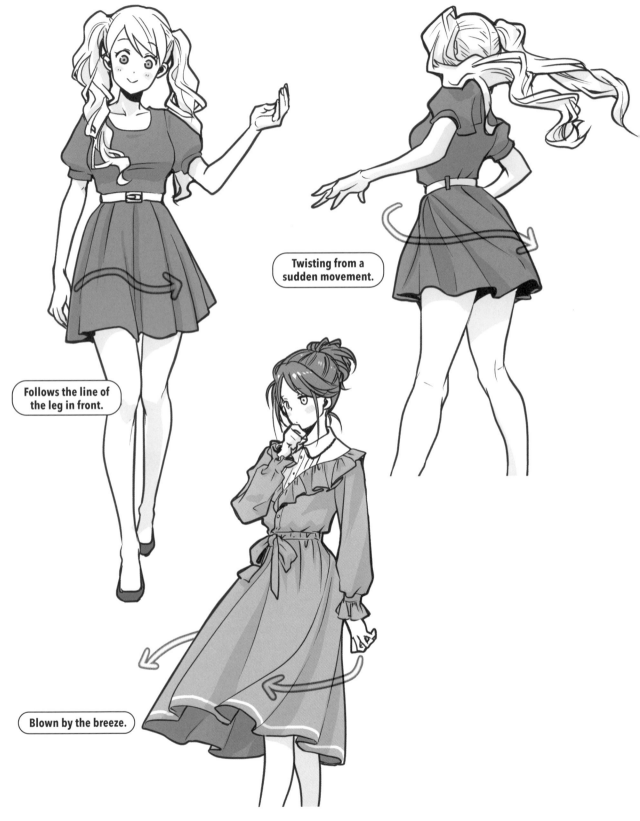

Twisting from a sudden movement.

Follows the line of the leg in front.

Blown by the breeze.

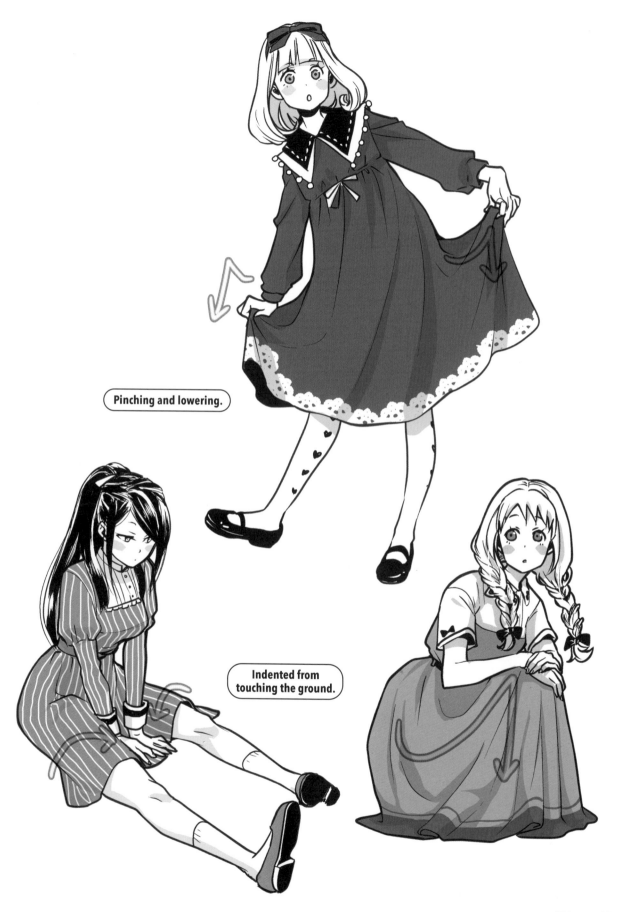

Pinching and lowering.

Indented from touching the ground.

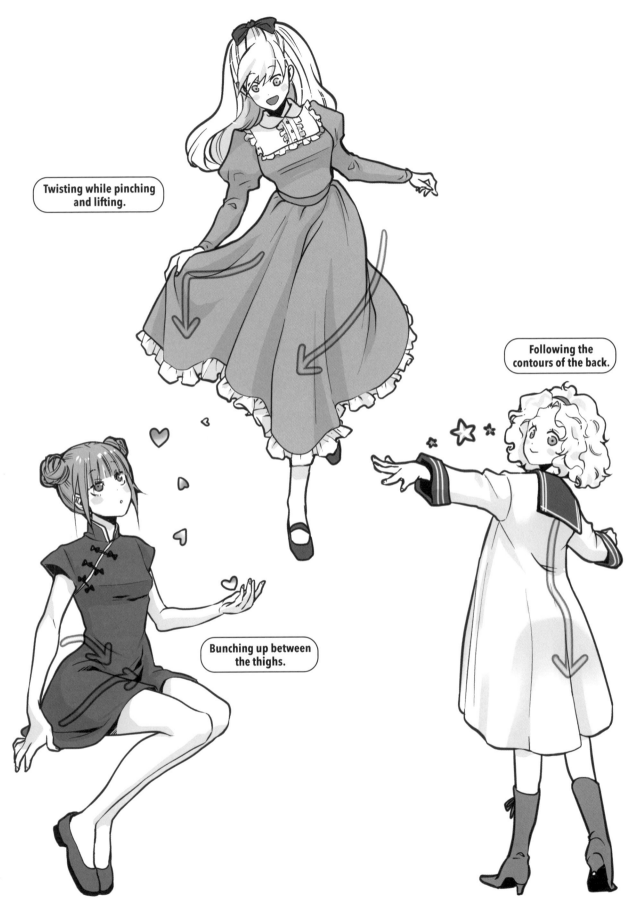

Twisting while pinching and lifting.

Following the contours of the back.

Bunching up between the thighs.

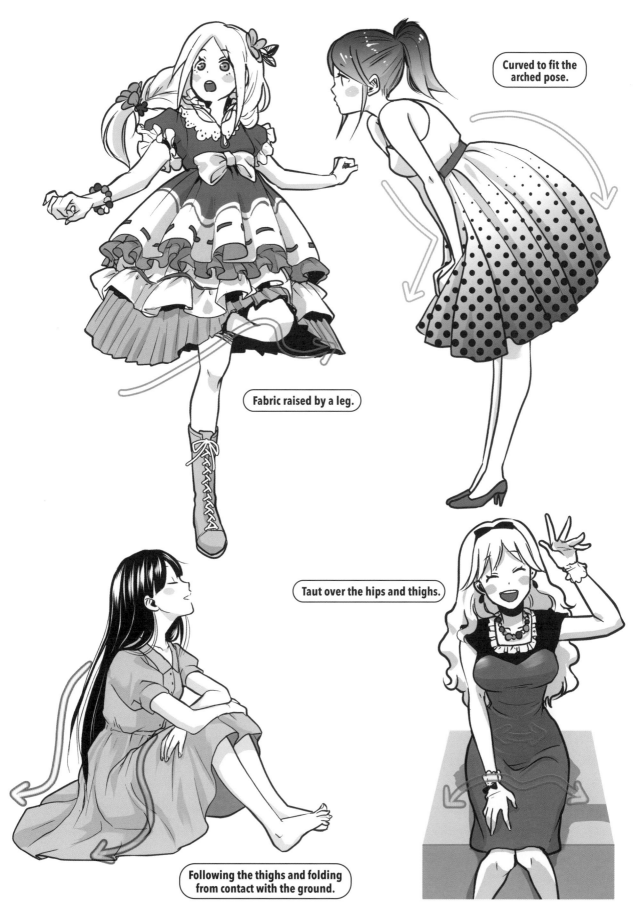

Curved to fit the arched pose.

Fabric raised by a leg.

Taut over the hips and thighs.

Following the thighs and folding from contact with the ground.

Sneakers

They're popular around the world for a reason. All ages have embraced this wide-ranging category of casual footwear. For some artists, it's their favorite thing to draw due to the variety of styles and designs to look to for inspiration.

Types of sneakers

From casual styles for walking in the city to high-performance sneakers designed for sports and working out, let's take a closer look at these popular athletic and casual shoes.

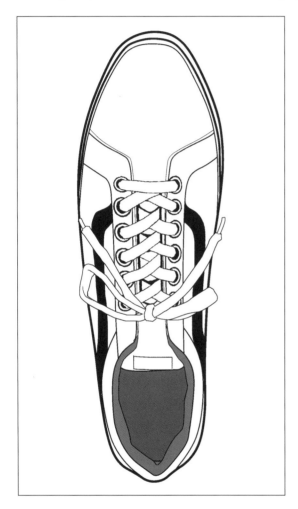

Slip-on

This type of sneaker has no shoelaces and is worn by being slipped onto the foot.

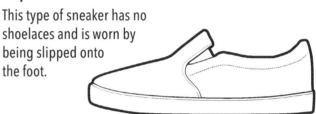

Low-cut

Sneakers cut low so that the ankles are clearly visible.

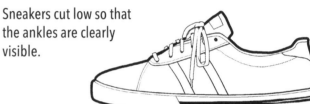

Mid-cut

The ankles are partially supported but not completely. This type is common for basketball shoes.

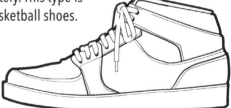

Athletic sneakers

This type of sneaker has various features designed for improved comfort when running or playing sports. The shape of the sole is often unique.

High top

This type is high enough to cover the entire ankle. They're also popular as basketball shoes.

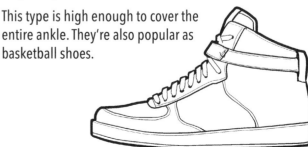

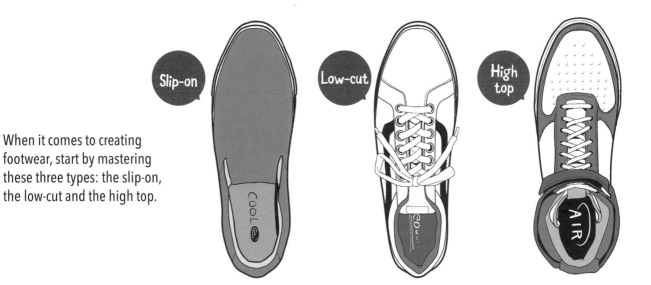

When it comes to creating footwear, start by mastering these three types: the slip-on, the low-cut and the high top.

Basic drawing method

Side View

1 Before drawing the shoe, start by drawing the foot. Divide the foot into three sections, following its shape: the toes, instep and heel. Visualize combining the block for each to create the shape of the shoe.

2 Draw in the thickness of the sole and round out the blocks to follow the shape of the foot. Slightly raise the toe area of the sole off the ground for a more realistic look.

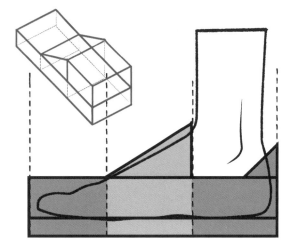

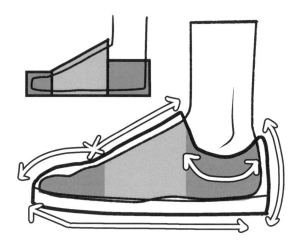

3 Add details to the blocking in from step 2. Draw in the tongue of the shoe to cover the instep and add the elastic or eyelets.

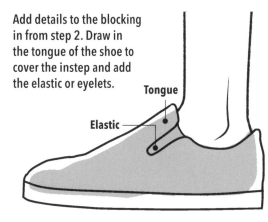

Tongue

Elastic

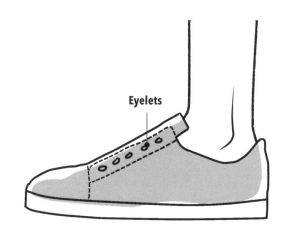

Eyelets

4 Add the details to suit the style of your illustration. If the drawing is meant to be realistic, it's a good idea to add in stitching and details on the sole.

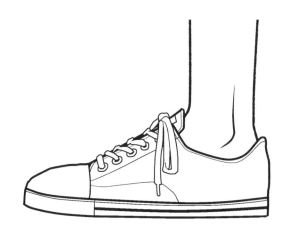

Viewed from an angle (inner side • outer side)

1

When drawing shoes on an angle, start by drawing the feet. Note that there's a difference between the inside and outside of the foot in the outline. Block in the shape of the shoe as if combining three blocks together.

2

Visualize a box surrounding the foot and round out the block.

3

Add in parts such as the tongue and sole to adjust the design.

Front and back view

Draw the shoe viewed from the front and back by creating blocks as well, paying attention to the position of the ankle. The ankle is higher on the inner side than on the outer side.

Ankle

Drawing various angles

⊙ Low-cut

The shoe viewed from the inner side. The key point is the hollow around the arch. When it's difficult to grasp the sense of dimension, it's a good idea to draw the shape of the soles.

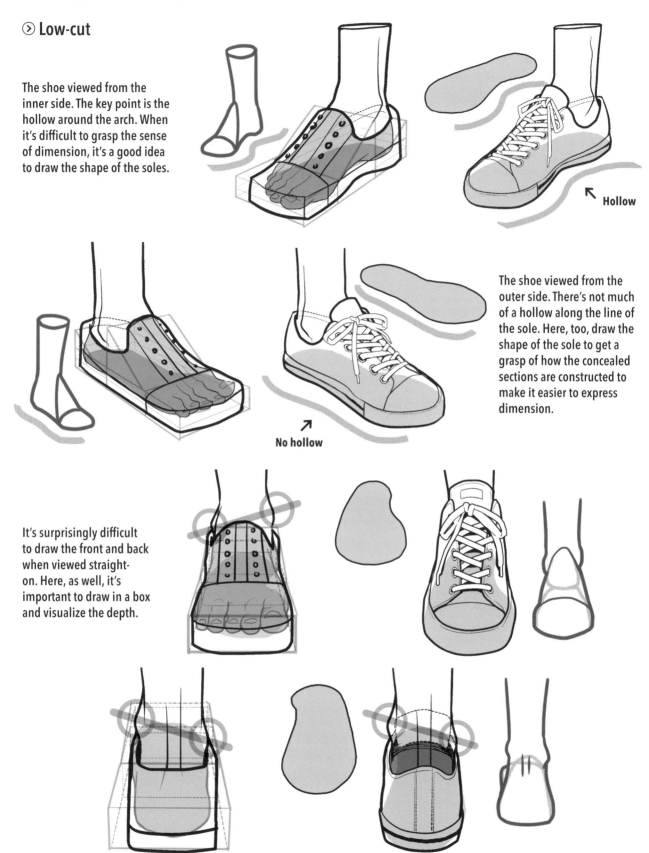

Hollow

No hollow

The shoe viewed from the outer side. There's not much of a hollow along the line of the sole. Here, too, draw the shape of the sole to get a grasp of how the concealed sections are constructed to make it easier to express dimension.

It's surprisingly difficult to draw the front and back when viewed straight-on. Here, as well, it's important to draw in a box and visualize the depth.

⊙ High-cut

In the case of high-cut sneakers, create a tall block for the heel section. The block for the instep is on more of an incline. Adding details to show the thickness of the material creates the look of basketball shoes.

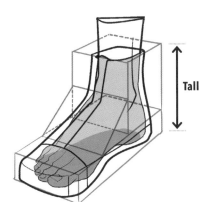

Tall

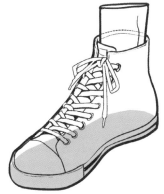

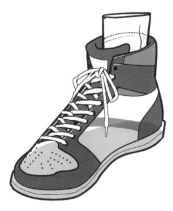

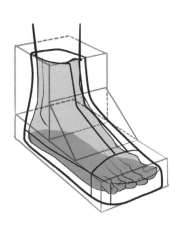

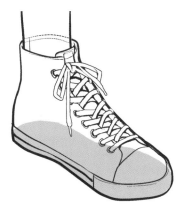

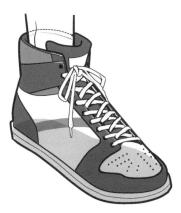

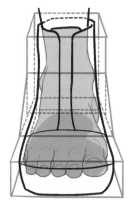

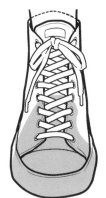

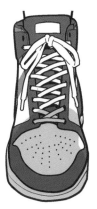

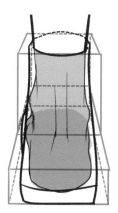

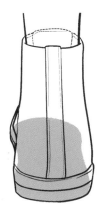

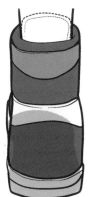

Differences in silhouettes

Whether they're sneakers for regular use, stylish dress sneakers or something to wear for running or working out, when you want to draw sneakers to suit the character and the scene, it's more important to capture and convey the silhouette than the fine details.

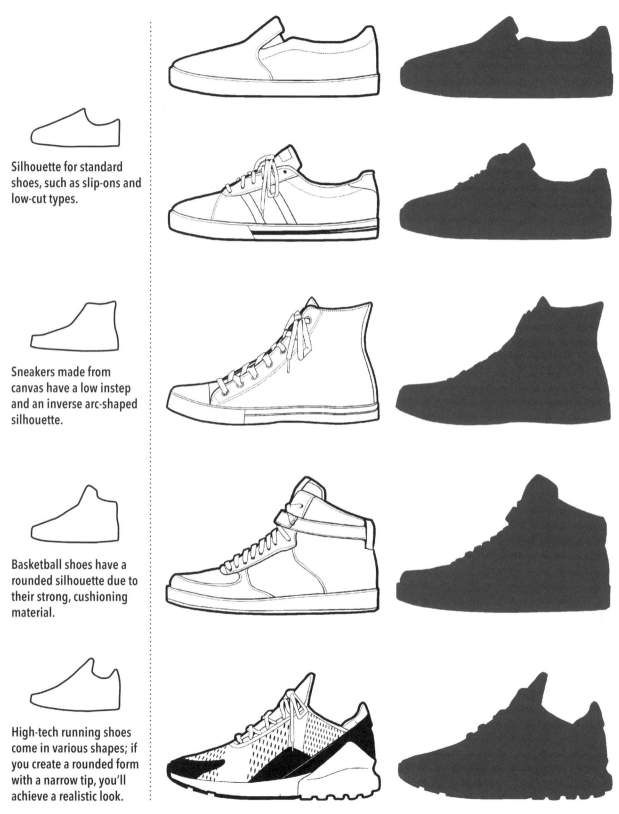

Silhouette for standard shoes, such as slip-ons and low-cut types.

Sneakers made from canvas have a low instep and an inverse arc-shaped silhouette.

Basketball shoes have a rounded silhouette due to their strong, cushioning material.

High-tech running shoes come in various shapes; if you create a rounded form with a narrow tip, you'll achieve a realistic look.

Viewed from an angle. For both slip-ons and low-cut sneakers, the regular types are made from thin material. Most have rounded toes.

Sneakers for sport

Although they're also high-cut sneakers, the instep is low for canvas types. When drawing running or athletic shoes, make the instep higher to create thickness in order to distinguish them.

High-tech sneakers use fabric with cushioning and have a puffed-out look to them. Make the toe section narrow and create a slight arc in the sole for a realistic look.

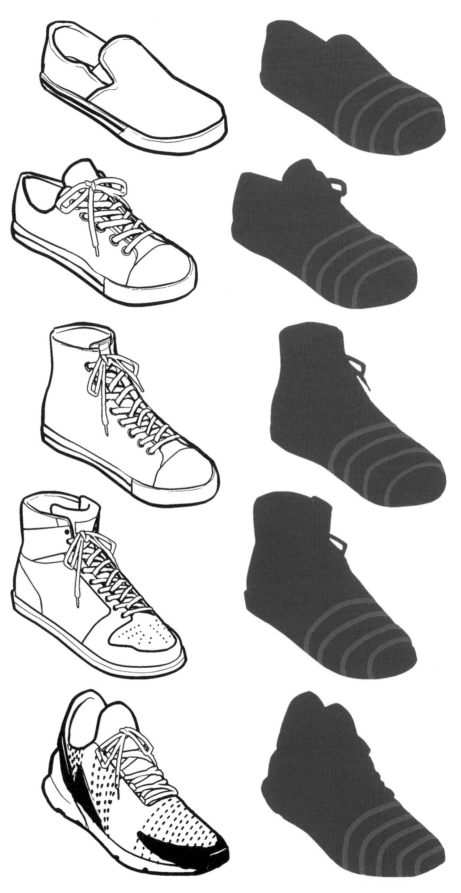

Simplified shoes

In manga panels and other illustrations where shoes appear scaled down, drawing in too much detail will make the image cluttered. Draw shoes in a simplified manner to integrate them in an unobtrusive way.

Low-level simplification

The details of the fabric, such as the stitching, are omitted.

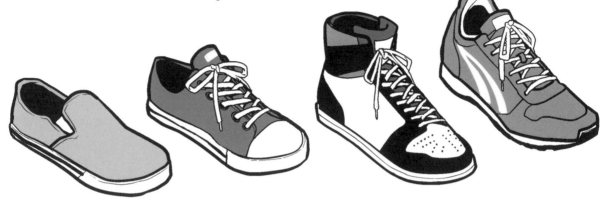

Regular simplification

Details such as the eyelets and soles are omitted.

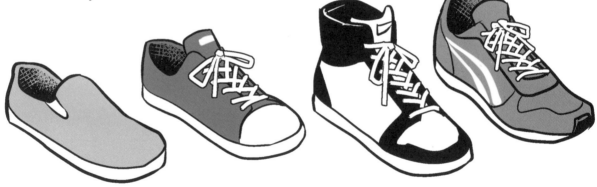

High level of simplification

These examples involve as little drawing as possible, with only the shape and design captured.

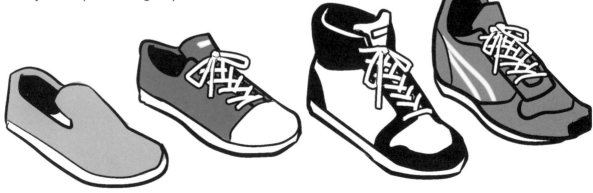

If you have the silhouette (see pages 76 and 77) in mind, even if you include only simplified details, it will still read as a proper sneaker.

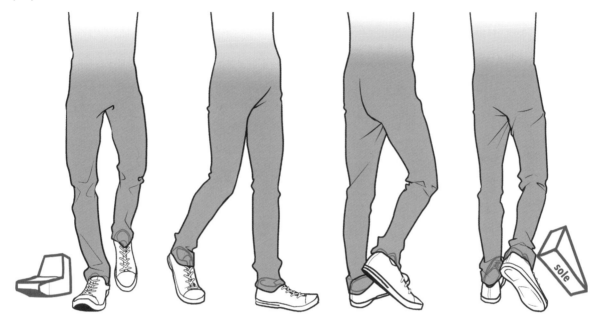

Even in a pose with movement, it's important to capture the silhouette of the sole when its shape alters. If you can do that, even if the details are rough, the overall result will look realistically contoured.

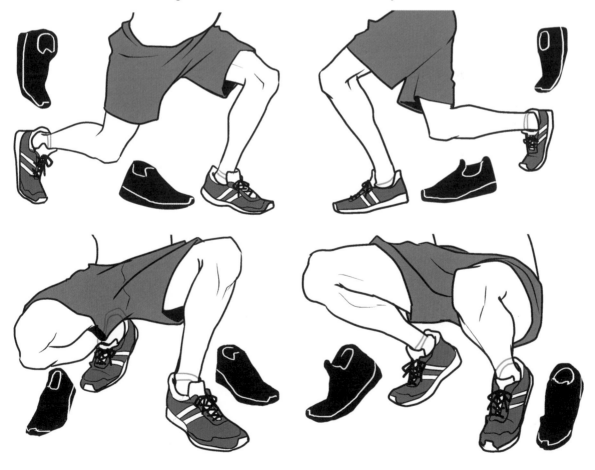

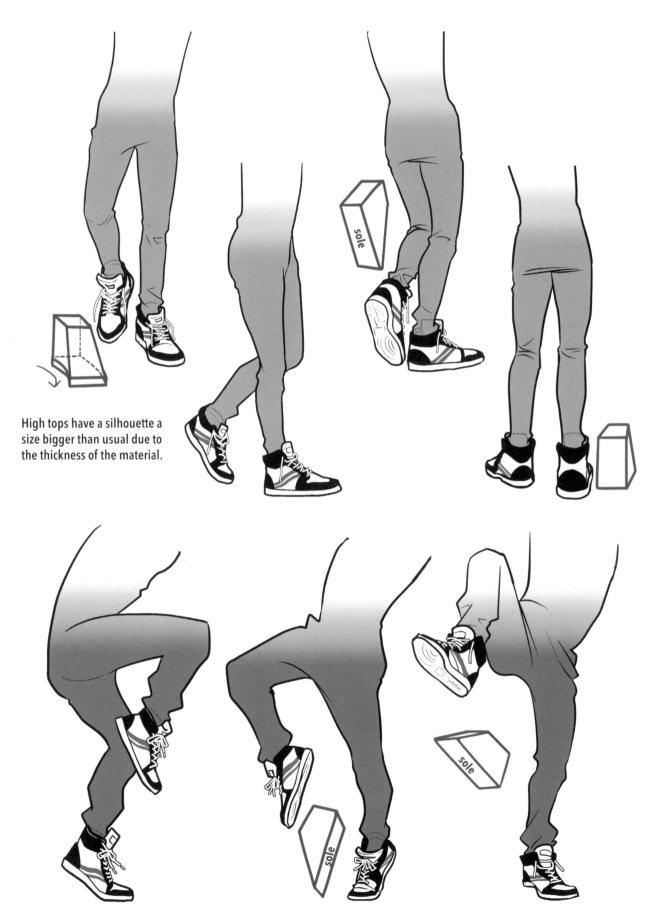

High tops have a silhouette a size bigger than usual due to the thickness of the material.

How to draw shoelaces

Types of shoelace

There are various types of shoelaces: flat ones that don't undo easily, sturdy rounded types and rounded flat versions that combine the features of both. When drawing illustrations, learn the flat cord and rounded cord as basics.

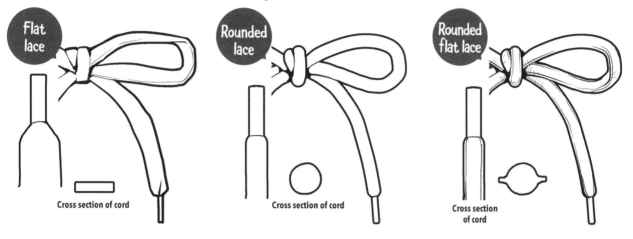

Flat lace
Cross section of cord

Rounded lace
Cross section of cord

Rounded flat lace
Cross section of cord

Differences in lacing

There are also various ways to lace shoes, but let's start by mastering the standard overwrap and underwrap. Threading the cord from above the eyelet is overwrapping; threading it from beneath the eyelet is underwrapping.

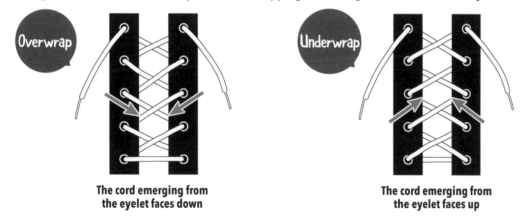

Overwrap
The cord emerging from the eyelet faces down

Underwrap
The cord emerging from the eyelet faces up

How to draw laces by hand

Draw overlapping x shapes, then use correction fluid to erase the lines underneath at the points where they cross to create neat, unified lacing.

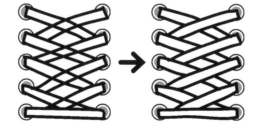

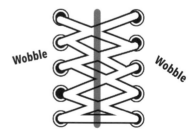

Wobble Wobble

If the intersection points are not lined up in the center, the effect will be a bit wobbly.

⊙ How to draw laces digitally

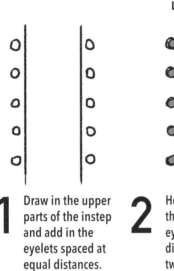

Layer 1 Layer 2

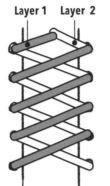

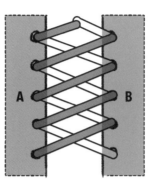

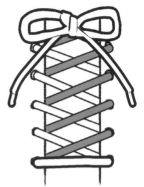

1 Draw in the upper parts of the instep and add in the eyelets spaced at equal distances.

2 Here, the shoelace goes through the top of the eyelet. The trick is to divide the shoelaces into two layers. Draw in the lines going diagonally up from the eyelets.

3 Erase the parts that are concealed by the uppers. Use the "selected area" tool to select part A in layer 1 and delete it. Do the same for part B in layer 2.

4 Create a new layer and draw in the horizontal cord at the bottom and the bow at the top to complete.

Shoelaces can be easily drawn by using software with a border function. Place one layer over the drawing and select "Border Effect: Outline" from Layer Properties. If you draw the lines from the eyelets at left, working diagonally down to the right, it will be outlined with the border effect and appear as a cord. Add another layer over the top and draw from the eyelets at right diagonally down to the left to complete the illustration.

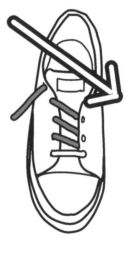

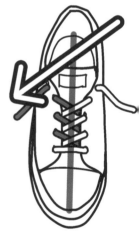

When it's not necessary to create realistic lacing, it's possible to simply use one layer and make a row of Xs to create the look.

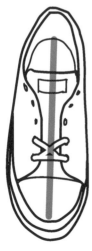

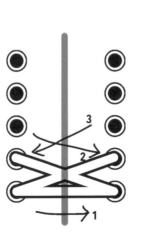

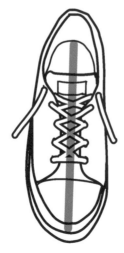

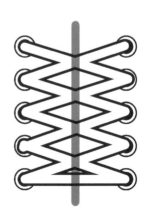

CHAPTER

2

Business Wear

Office and business wear is rapidly changing as more casual
styles and pieces are becoming increasingly commonplace.
Whether it's business casual or the suit-and-tie formality of
the corporate look, business wear offers your characters a
whole new world of refined attire.

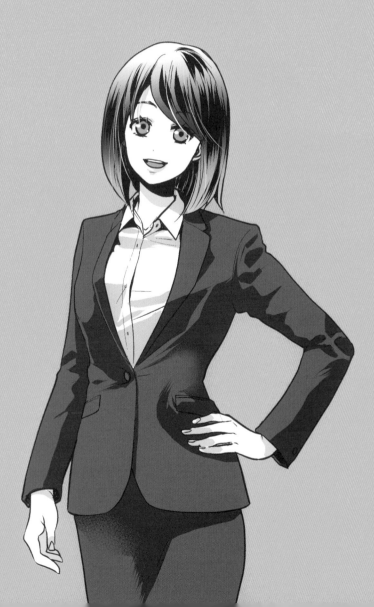

Jackets

When it comes to suit jackets, the two-button style is increasingly common. Since blazers are more fitted than casual jackets, they're characterized by the shape around the shoulders and the creases that appear when the wearer moves.

Basic fabrics

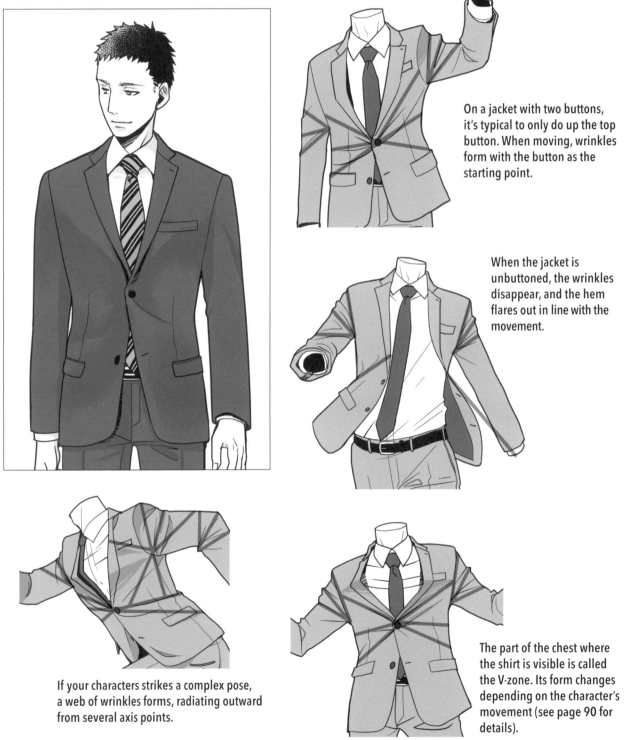

On a jacket with two buttons, it's typical to only do up the top button. When moving, wrinkles form with the button as the starting point.

When the jacket is unbuttoned, the wrinkles disappear, and the hem flares out in line with the movement.

If your characters strikes a complex pose, a web of wrinkles forms, radiating outward from several axis points.

The part of the chest where the shirt is visible is called the V-zone. Its form changes depending on the character's movement (see page 90 for details).

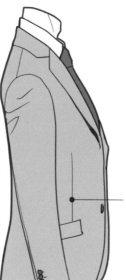

On a jacket that is fitted to the body, hardly any creases form in the back. On an ill-fitting or baggy jacket, horizontal creases form beneath the neck.

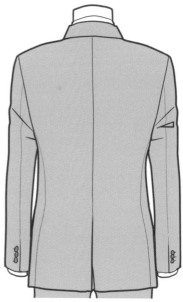

When a character is standing with arms down at the sides, there are barely any wrinkles in the sleeves. The line on the front is a dart (a seam line to narrow the waist).

Dart

Moving the arms reveals the line of the side seam, where fabric is sewn together. However, from far away, darts and seamlines are barely visible, so it's O.K. to leave them out of illustrations if you like.

Seamline

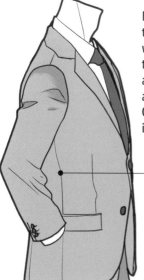

Viewed on an angle from behind, the sleeve seams and back seam are visible. Again, depending on the style of the illustration or your personal preference, these can be omitted.

Seamline

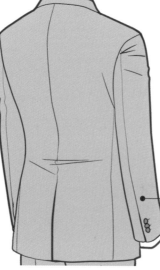

The slit in the back of the jacket is called the center vent. The opening in the slit widens during certain movements.

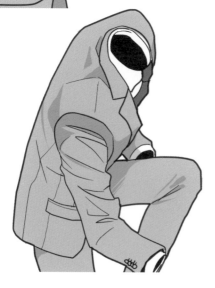

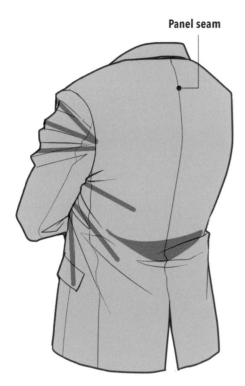

Panel seam

The center back seam forms a smooth, curved line. When the arms are folded, wrinkles form with the underarms as starting points, and horizontal creases appear at the waist.

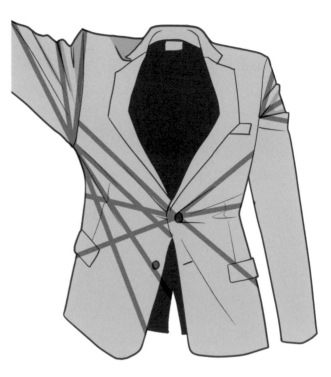

The shoulder, underarm and the top button send out a simultaneous web of wrinkles.

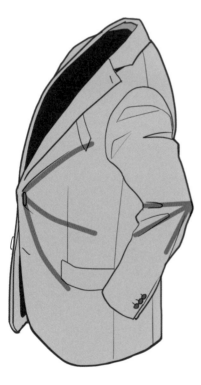

Wrinkles in the sleeve start at the elbow and under the arm.

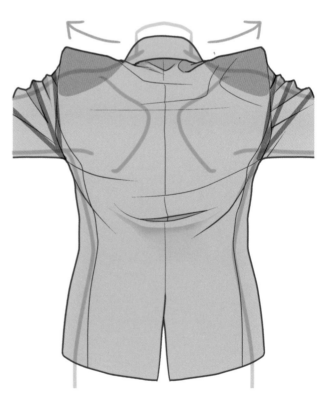

Inside the shoulders of some jackets are pads. When both arms are raised, the pads are shifted to the center, and their edges lift.

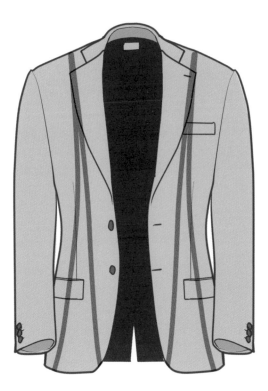

In casual settings or when worn without a necktie, the jacket is often unbuttoned. In these cases, the starting point for wrinkles shifts to the shoulders.

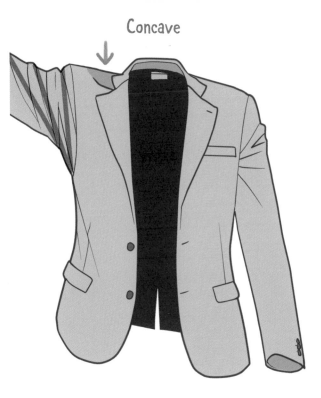

Concave

When the arms move, wrinkles form in the underarm area, but not along the chest.

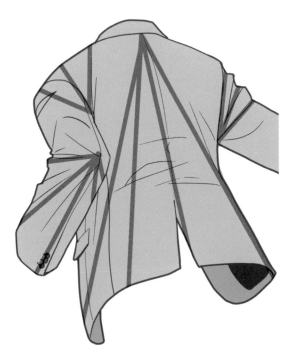

The front of the jacket is unbuttoned, so in the back, wrinkles radiate from beneath the neck.

Concave

When both arms are raised, the body of the jacket lifts and opens out to form a ⁄ ＼ shape.

Three-dimensional jackets

Compared with cut-and-sewn garments, suit jackets are more precisely shaped. When you want to draw them from various angles, it's easier to grasp a sense of their dimensionality if you start by drawing a box.

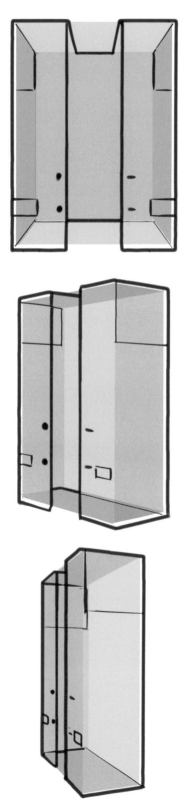

Now try drawing a jacket as if using it to cover a box. You'll notice various differences depending on the angle, such as the collar being visible or not and the position of the buttons appearing high or low.

The different shapes of the V-zone

The part of the shirt and tie that are visible when worn with a jacket is called the V-zone. When your character is in motion, this area changes shape in unique ways, so consider these tips and tricks.

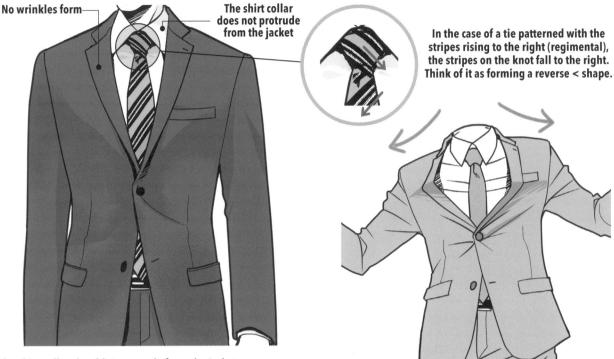

No wrinkles form

The shirt collar does not protrude from the jacket

In the case of a tie patterned with the stripes rising to the right (regimental), the stripes on the knot fall to the right. Think of it as forming a reverse < shape.

The shirt collar shouldn't protrude from the jacket, creating a dimple in the necktie beneath the knot.

Even the normally neat V-zone changes shape when a character's in motion.

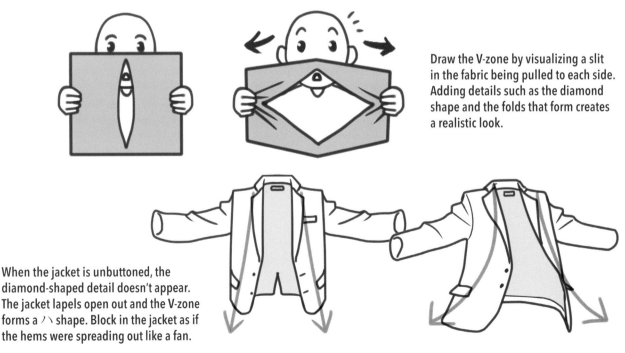

Draw the V-zone by visualizing a slit in the fabric being pulled to each side. Adding details such as the diamond shape and the folds that form creates a realistic look.

When the jacket is unbuttoned, the diamond-shaped detail doesn't appear. The jacket lapels open out and the V-zone forms a ⁄ ＼ shape. Block in the jacket as if the hems were spreading out like a fan.

How to treat the area around the shoulders

Some suit jackets have pads on the inside to create an attractive shoulder line. So it often helps to visualize these internal pads when drawing the upper portion of blazers.

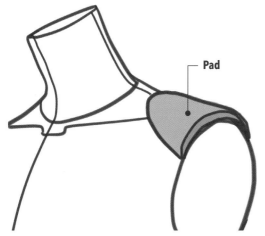

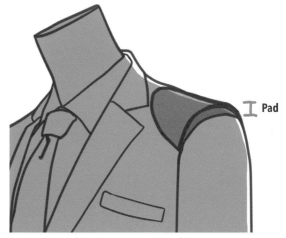

When a jacket has shoulder pads, it gives the impression of a firm, solid shape, even on people with sloping shoulders. Not all jackets have shoulder pads, but it's helpful to imagine they do when drawing.

As a rule, wrinkles don't form in the shoulder pads, but they do form in the area below the thickness of the pad. Blocking in the pad hidden on the inside of the garment allows you to be aware of the volume created by the pad.

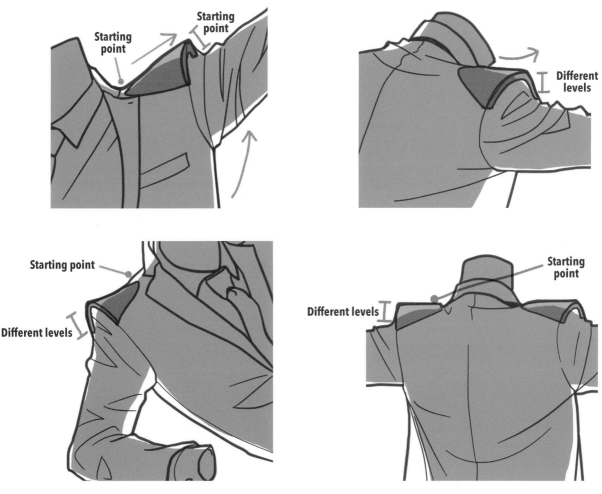

Positioning for each part of the jacket

There are all kinds of designs for suit jackets, with a variety of number of buttons and pocket positions. While tastes and fashions change and trends come and go, it's good to get a strong sense of the construction and shape of a basic blazer.

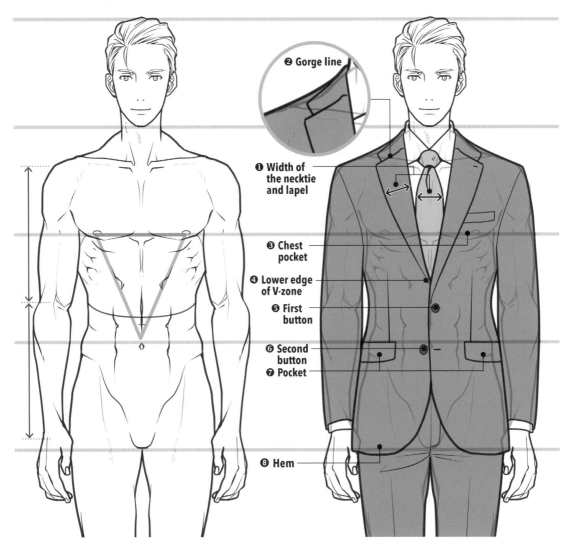

❷ Gorge line

❶ Width of the necktie and lapel

❸ Chest pocket

❹ Lower edge of V-zone

❺ First button

❻ Second button

❼ Pocket

❽ Hem

The picture shows a character eight heads tall. The chest is usually about two heads down from the top, with the navel at a position three heads down. The distance from shoulder to hip and hip to groin is about the same.

An example of the single-breasted two-button suit, well-tailored to fit the character's shape and frame.

① Make the width of the necktie and lapel the same. A narrow width creates a youthful impression, while wider widths make for a dignified look.

② The line where the upper and lower parts of the collar meet is called the gorge line. Its position moves higher or lower depending on trends, but it's safe to place it higher than the bottom edge of the shirt collar (about midway up).

③ The chest pocket is at about the same height as the nipples.

④ The width of the V-zone also changes depending on design and trends, but placing the lower edge at about the solar plexus creates the basic look.

⑤ In the case of a two-button suit, the first button is about 2.5 heads down.

⑥ The second button is at around the height of the navel or slightly lower.

⑦ The pockets should be around the height of the second button.

⑧ The hem should be at a length so that it covers the buttocks.

Suit movements

In manga and anime, as well as in action blockbusters, characters perform cool moves in fight scenes while wearing suits. So it's time to explore how a blazer billows and moves during intense or acrobatic action sequences.

Running

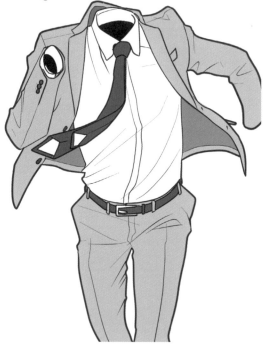

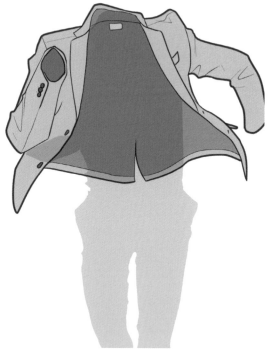

If the jacket is buttoned, mobility is limited, so active characters in suits tend to leave their blazers open. The jacket hem flaring out is a key point for creating a sense of dynamism and flow.

Capturing the form and shape of the body parts that are concealed from sight makes for a realistic result.

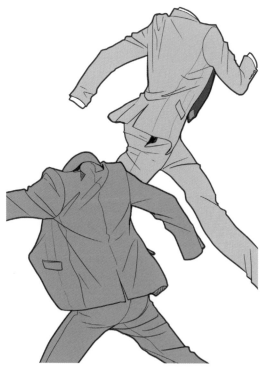

Sitting

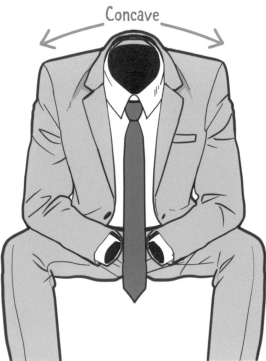

In a pose where the character is seated with a hunched or rounded back, the collar area appears to sink down.

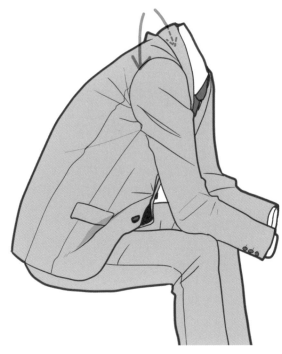

Viewed from the side, it's clear that both the neck and shoulders are tilted to the front.

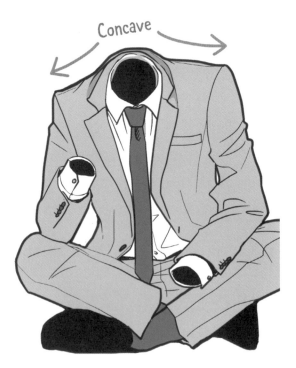

In a cross-legged pose, the back is also rounded, and the shirt collar sinks into the jacket.

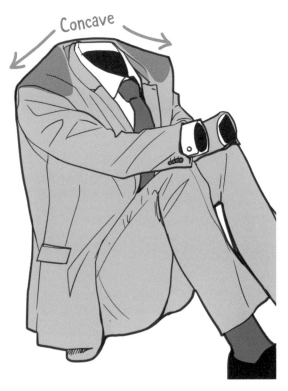

Leaning against a wall. The shoulders are raised, and the collar sinks down.

Acrobatic movements

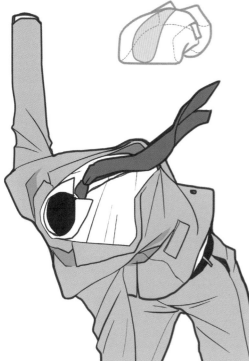

Start by blocking in the torso to get a grasp of its construction before drawing in the arms and legs.

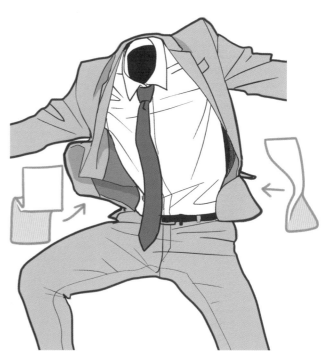

To capture the flow of fabric following a sudden movement, block it in to get a grasp of the form before drawing.

Lunging or leaning in: the left shoulder drops and the line of the collar along with it.

When the buttons are left undone, the front of the jacket moves quite freely. The top button restricts that range of motion, creating a rigid triangle up top.

Business Shirts

When it comes to button downs or dress shirts, the construction of the collar and sleeves seem to present particular difficulty for many people when drawing. Let's take a look at some of the fine details, including of course how wrinkles are formed.

Basic shape and creases

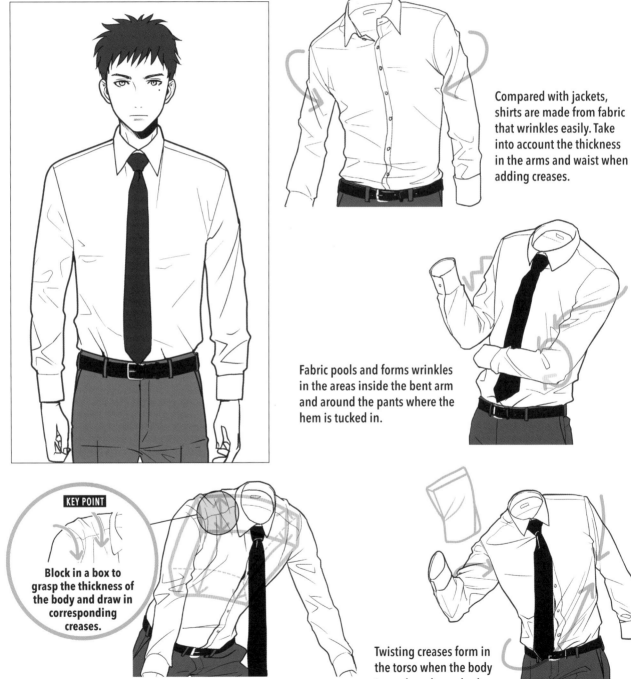

Compared with jackets, shirts are made from fabric that wrinkles easily. Take into account the thickness in the arms and waist when adding creases.

Fabric pools and forms wrinkles in the areas inside the bent arm and around the pants where the hem is tucked in.

KEY POINT

Block in a box to grasp the thickness of the body and draw in corresponding creases.

When leaning over, the necktie hangs down at a distance from the body. Some people wear tietacks so the tie doesn't hang loose.

Twisting creases form in the torso when the body turns. Imagine wringing out a sponge.

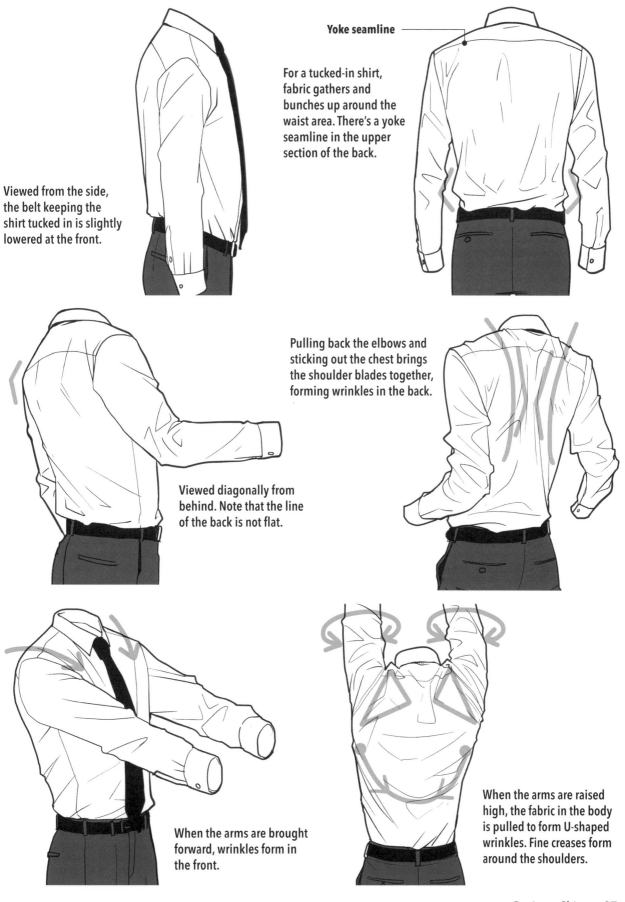

Yoke seamline

For a tucked-in shirt, fabric gathers and bunches up around the waist area. There's a yoke seamline in the upper section of the back.

Viewed from the side, the belt keeping the shirt tucked in is slightly lowered at the front.

Pulling back the elbows and sticking out the chest brings the shoulder blades together, forming wrinkles in the back.

Viewed diagonally from behind. Note that the line of the back is not flat.

When the arms are brought forward, wrinkles form in the front.

When the arms are raised high, the fabric in the body is pulled to form U-shaped wrinkles. Fine creases form around the shoulders.

The area around the collar

Many people have difficulty drawing the area around the collar. It's easier to conceive if you start by visualizing a cylindrical shape to block in the neck area, then add in the collar.

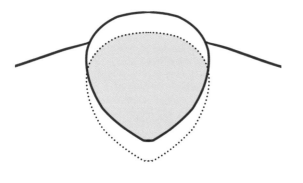

Draw the neck area as if it were a cylinder. The picture shows a slightly overhead view, so the ridge of the shoulders is higher than usual.

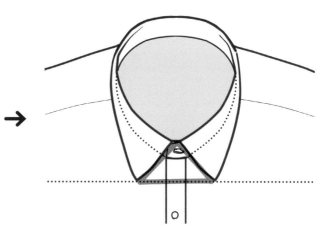

Block in a triangle in the center, and use it as a guide to draw in the collar.

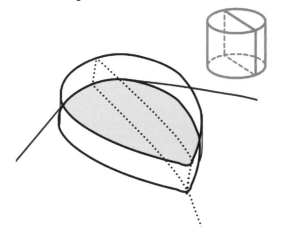

When drawing the figure viewed on an angle, block in the center of the cylinder to work out where the center of the chest will be.

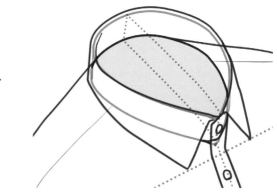

Add in the collar. Draw in diagonal blocking-in lines to match the lean of the body and to align the corners of the collar accordingly.

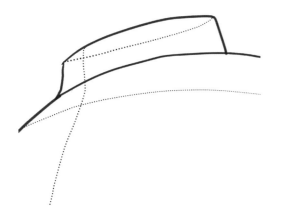

The figure drawn from below. The lower part of the cylinder is hidden by the chest.

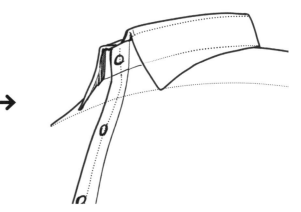

Add in the collar. On a man's shirt, the left side overlaps the right.

From blocking in to completion

If you continue drawing after blocking in the area around the character's neck, you'll create a collar area with a strong sense of dimension.

Regular collar

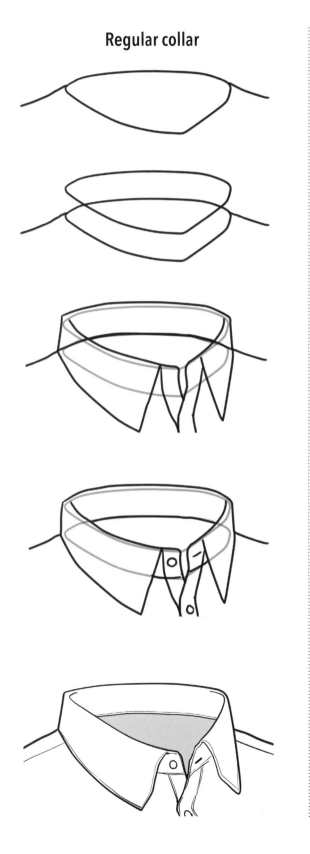

Open collar

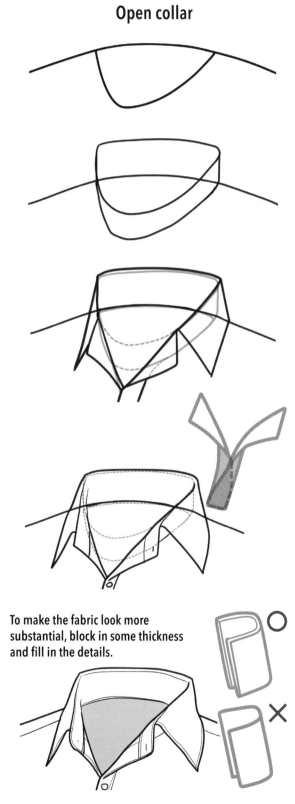

To make the fabric look more substantial, block in some thickness and fill in the details.

The whole shirt

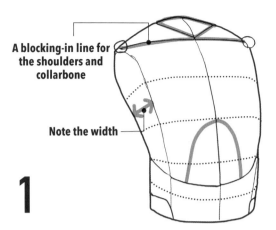

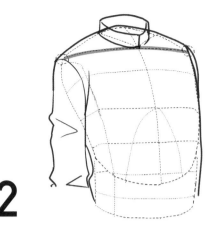

A blocking-in line for the shoulders and collarbone

Note the width

1

Block in the torso and waist area to create a sense of thickness. Block in the shoulder area so it's shaped like a clothes hanger.

2

Block in a cylinder for the neck section that will create a platform on which to draw the collar. Add the sleeves so they slope down from the shoulders.

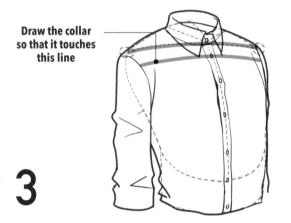

Draw the collar so that it touches this line

3

Draw in the collar and fill in the placket (the section where the buttons are lined up vertically) on the front of the shirt using a ribbon-like shape. Make sure the tips of the collar touch the line parallel to the blocking-in line for the shoulders.

4

Erase the blocking in and adjust the details.

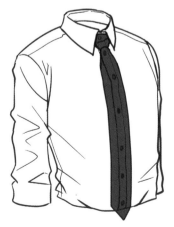

If drawing a necktie, the tip should touch the belt at the waist.

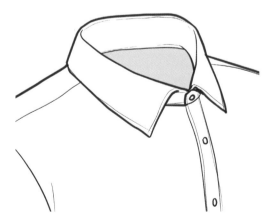

A close-up of the collar. The back of the collar will be hidden by the character's neck, but drawing with an understanding of the shape will make for a natural and realistic result.

Positioning the cuffs

The cuffs offer finish and refinement. When drawing them, it's easy to mistake the position of the buttons, so be particularly careful when rendering that detail.

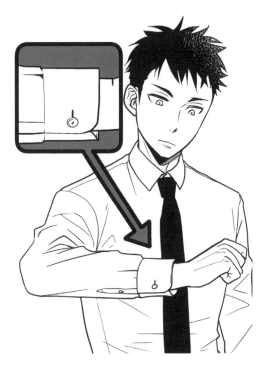

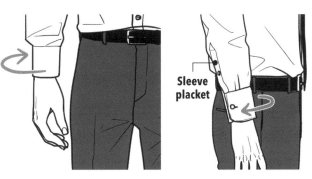

The cuff fabric overlaps from the inside to the outside of the arm. The button should be placed in line with the little finger.

The cuff button is on the same side as the little finger. From the index-finger side, the button is concealed and can't be seen. It's visible when viewed from the side. Don't forget to draw the sleeve placket detail, which is the slit section of the sleeve.

Sleeve placket

The fabric is overlaid from the inside of the arm over the outside. In frames where both arms are visible, make sure not to get this wrong.

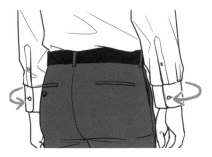

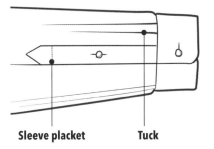

Sleeve placket **Tuck**

An enlargement of the sleeve placket area. Properly capturing this detail increases the authenticity of the shirt.

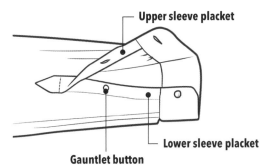

Upper sleeve placket

Lower sleeve placket

Gauntlet button

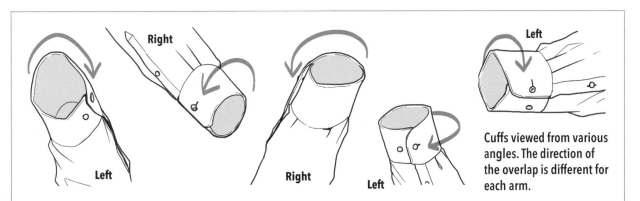

Right

Left

Left

Right

Left

Left

Cuffs viewed from various angles. The direction of the overlap is different for each arm.

Comparison of wrinkles

⊙ Differences in wrinkles depending on fabric

Button-down shirts are made from thin fabrics such as cotton and polyester. Drawing in sharp creases that don't have much of a curve will make for a realistic look. Curved, softer wrinkles suit shirts made from knitted fabrics.

Button down

Shirt made from knitted fabric

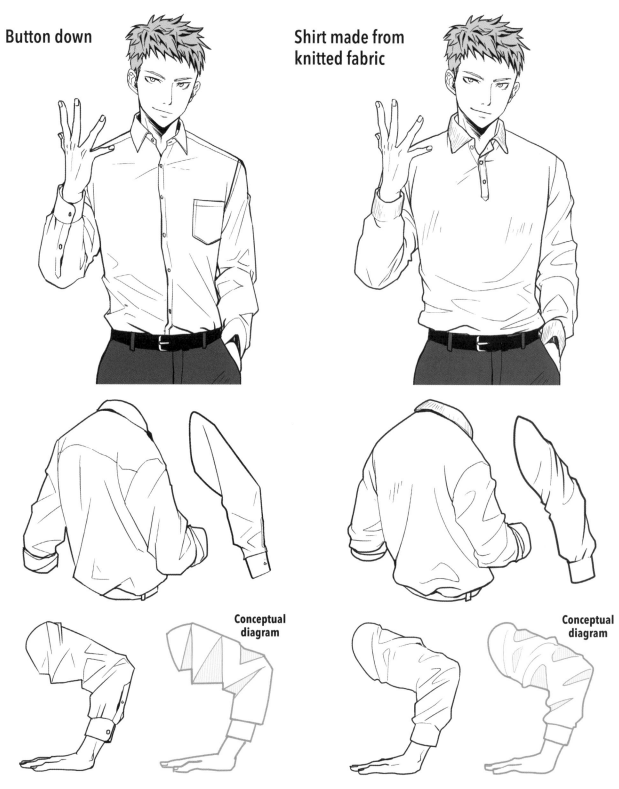

Conceptual diagram

Conceptual diagram

⊙ Differences in wrinkles depending on sizing and styling

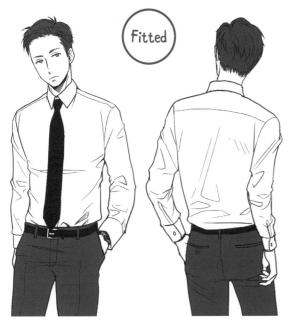

Fitted

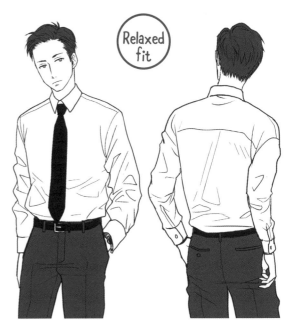

Relaxed fit

A look that pairs a fitted shirt with low-waisted slim pants. As the garments fit close to the body, the silhouette is slim and there are few wrinkles.

A look that pairs a slightly loose shirt with pants that have more room in the crotch. As the shirt is a larger size, there are more creases and the silhouette is larger as well.

KEY POINT

Yoke and back options

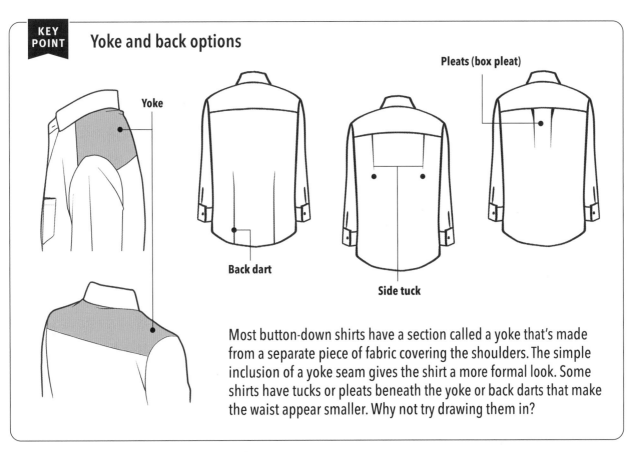

Yoke

Pleats (box pleat)

Back dart

Side tuck

Most button-down shirts have a section called a yoke that's made from a separate piece of fabric covering the shoulders. The simple inclusion of a yoke seam gives the shirt a more formal look. Some shirts have tucks or pleats beneath the yoke or back darts that make the waist appear smaller. Why not try drawing them in?

Vests & Waistcoats

Now more of a retro or highly formal style, a traditional three-piece suit is made up of a jacket, vest and pants made of the same material. Let's take a look just at the vest (also called a waistcoat or gilet), which is a good choice as a separate, standalone piece as well.

Basic shape and creases

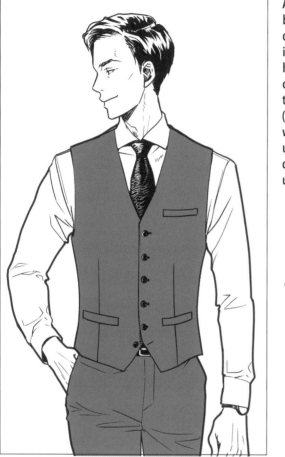

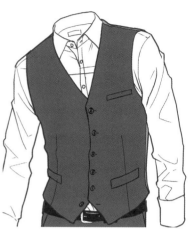

A collarless vest with six buttons, of which five are done up. The lowest button is in a place that makes it hard to fasten, so it's left open. Some designs have the lowest button done up (such as the five-button vest with all the buttons done up on page 107), but you can leave the lowest button undone if you prefer.

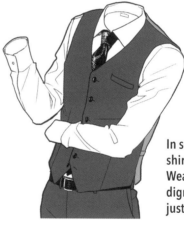

In some circles, the button-down shirt is worn like an undergarment. Wearing a vest creates a more dignified appearance than wearing just the shirt on its own.

Smooth fabric

The back of a vest in a three-piece suit is often made from a smooth, shiny fabric to make it more comfortable when wearing a jacket over the top.

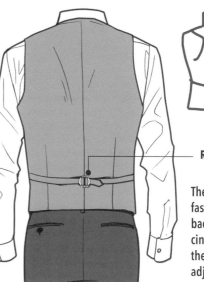

Draw the vest fitted to the body of the wearer to create a well-defined line. Create a simplified drawing of the torso on the inside of the vest to grasp the dimensions before adding in the vest.

Rear cinch

There is a metal fastening on the back called the rear cinch. This allows for the cinching to be adjusted.

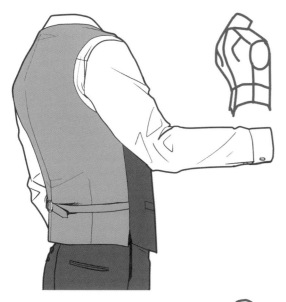

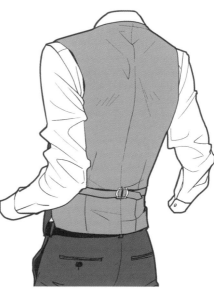

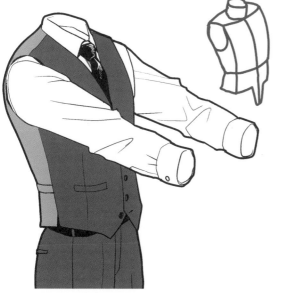

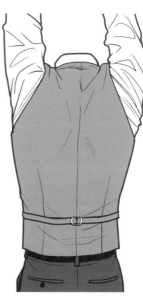

Comparison with a shirt only

Let's compare the look of the vest on the preceding page with the look of a shirt by itself. Drawing fewer wrinkles in a vest than in a shirt makes for an authentic look.

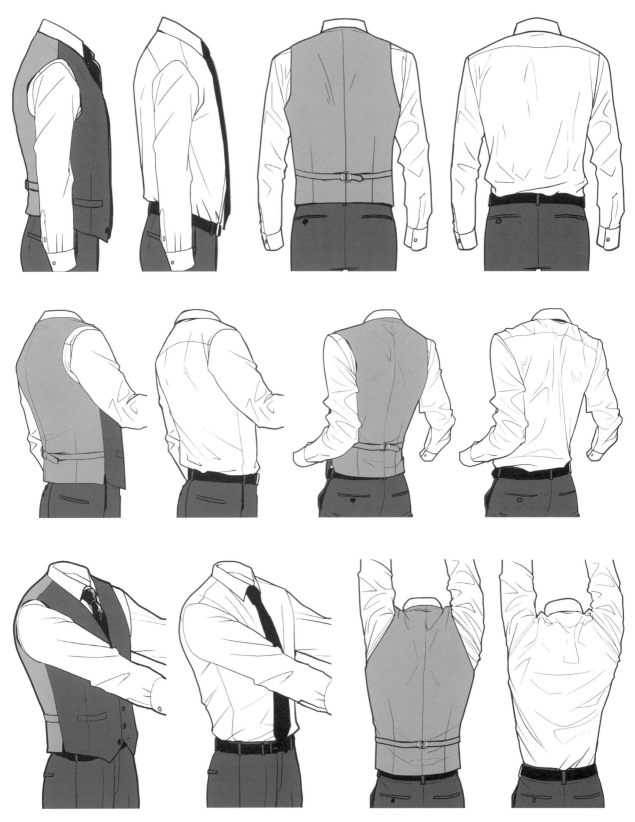

Positioning the parts

There are various designs of vests, but grasping the basic details and their positioning makes rendering them easier. Here the popular collarless single-breasted vest is the focus.

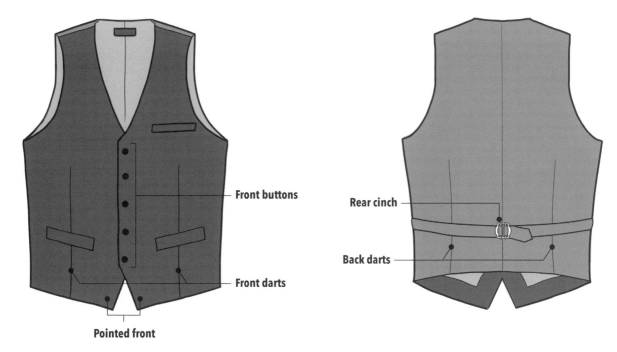

Front buttons

Front darts

Pointed front

Rear cinch

Back darts

The diagram shows a five-button single-breasted vest with all the buttons done up, including the one at the very bottom (it can be left open if you prefer).

The back of a vest in a three-piece suit is often made from the same thin fabric that's used for the jacket lining. The cinch is a metal fastening that allows the waist to be adjusted.

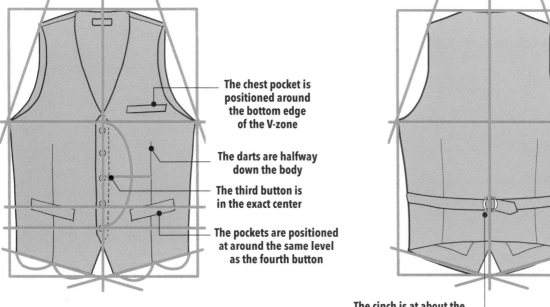

The chest pocket is positioned around the bottom edge of the V-zone

The darts are halfway down the body

The third button is in the exact center

The pockets are positioned at around the same level as the fourth button

The cinch is at about the same height as the pockets

Actual vests differ depending on their tailoring, but when drafting anime or manga or developing a cosplay design, draw the bottom of the V-zone and the armhole at the same level to create a strong, clean silhouette.

Vest variations

Vests come in various designs. Try coordinating the style to match and express the character's personality and defining qualities.

⊙ Comparing different vests

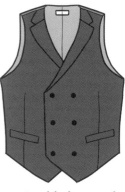

Collarless single-breasted	Collarless double-breasted	Single-breasted with collar	Double-breasted with collar
The most popular design, with a single row of buttons below the V-zone.	A design with two rows of buttons beneath the V-zone, adding complexity to the design.	A design with a collar similar to that of a jacket; it creates a slightly more formal look.	The most stately or classic design. It suits a dignified character.

The collarless single-breasted type is a clean, simple design. The type with a collar brings more volume to the chest, adding depth and dimensionality.

KEY POINT

Take time with the tie

Create a dimple below the knot to prevent the necktie from looking flat and to lift it slightly away from the front of the shirt and the collar.

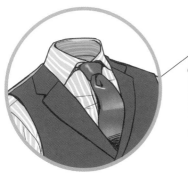

⊙ Effects of the V-zone

Basically, vests with fewer buttons have deeper or broader V-zones, while those with more buttons or with collars have shallower or narrower V-zones. The shallower the V-zone, the less surface area of the shirt is visible.

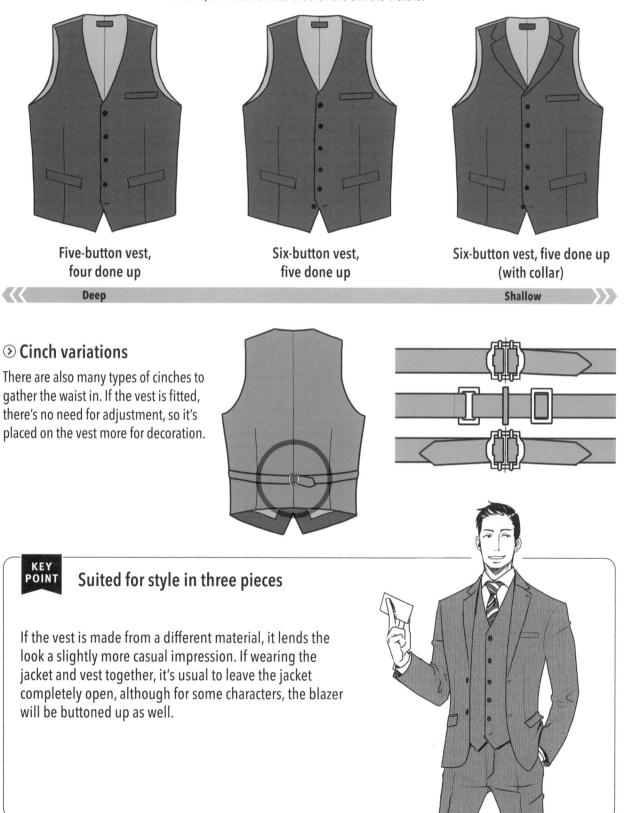

Five-button vest, four done up

Six-button vest, five done up

Six-button vest, five done up (with collar)

◄◄◄ **Deep** **Shallow** ►►►

⊙ Cinch variations

There are also many types of cinches to gather the waist in. If the vest is fitted, there's no need for adjustment, so it's placed on the vest more for decoration.

KEY POINT Suited for style in three pieces

If the vest is made from a different material, it lends the look a slightly more casual impression. If wearing the jacket and vest together, it's usual to leave the jacket completely open, although for some characters, the blazer will be buttoned up as well.

⊙ Other vest variants

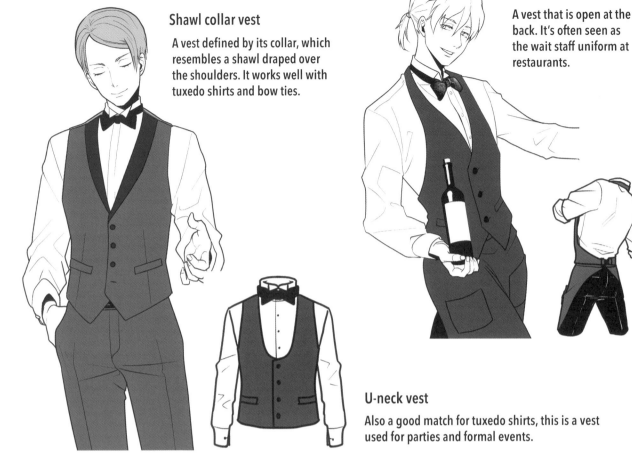

Shawl collar vest

A vest defined by its collar, which resembles a shawl draped over the shoulders. It works well with tuxedo shirts and bow ties.

Waiter's vest

A vest that is open at the back. It's often seen as the wait staff uniform at restaurants.

U-neck vest

Also a good match for tuxedo shirts, this is a vest used for parties and formal events.

KEY POINT **Business vs. casual vests**

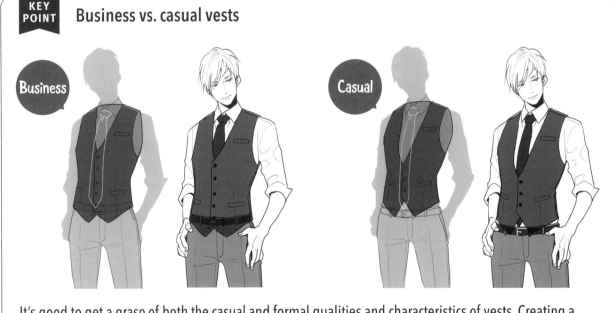

Business

Casual

It's good to get a grasp of both the casual and formal qualities and characteristics of vests. Creating a super-slim vest with a deep V-zone, keeping the number of buttons low, adding a narrow tie or making the belt visible are all effective ways of distinguishing the casual vest from the business version.

Checkpoints when things don't seem right

⟩ When it looks unrefined

Compare the two figures below wearing vests. The picture at left is somehow unrefined and imbalanced, right? Which parts do you think should be corrected or revised to achieve the stylish look of the picture on the right?

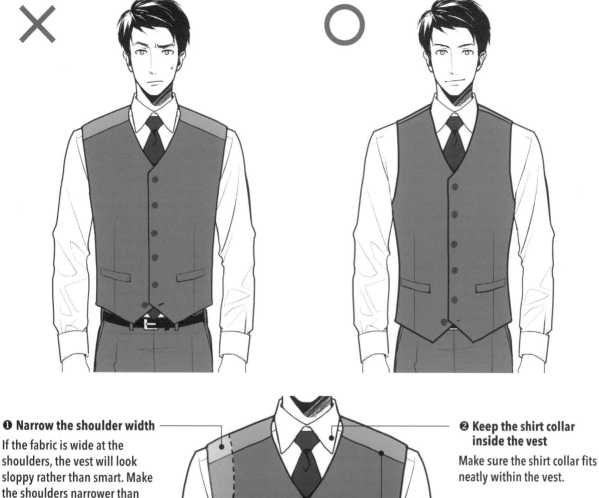

❶ Narrow the shoulder width

If the fabric is wide at the shoulders, the vest will look sloppy rather than smart. Make the shoulders narrower than that of the shirt.

❷ Keep the shirt collar inside the vest

Make sure the shirt collar fits neatly within the vest.

❸ Don't bring the back of the vest too far forward

Make sure the seam joining the front and back doesn't come as far forward as that of the shirt.

❹ Make sure the belt and necktie are not showing too much

It's O.K. for a little bit to be visible, but if too much of the belt and necktie can be seen, the vest will look too short.

Shirt example

Yoke

Shoulder

⊙ When it looks too flat and stiff

If the vest is too flat or stiff in appearance, try drafting in a simple torso using blocks. If you draw the vest as if putting it on over a block or box-like framework, you'll be able to properly express the body's dimensions.

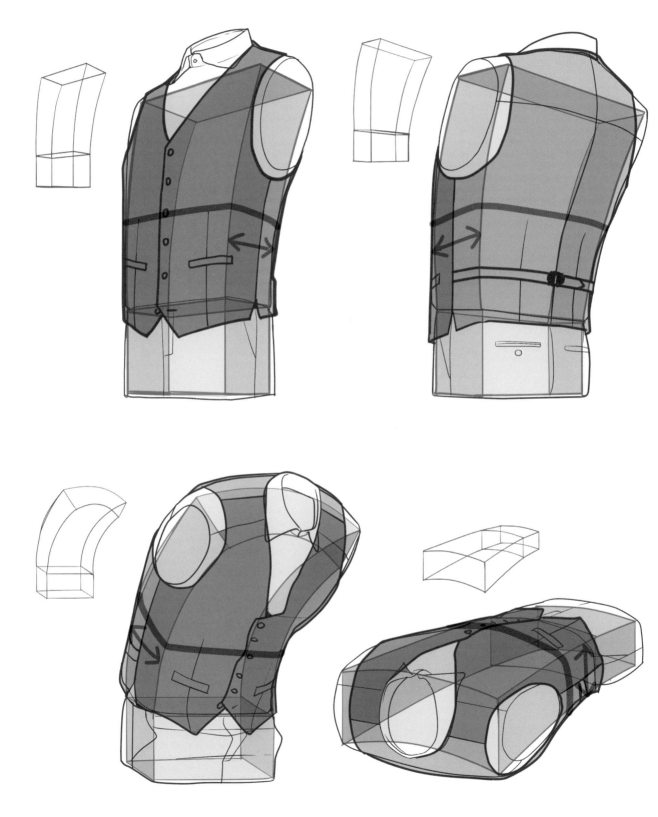

Paying attention to small details such as the sagging in the V-zone when the figure's bent forward, the diagonal line that forms toward the front edges and the gap that forms behind the shoulders allows you to draw vests in even more appealing and flexible ways.

Pants

Who wears the pants? Slacks, trousers, whatever you want to call them, they often feature a fold down the front part of the leg called a center crease. To suggest the wool or polyester-blend fabrics used to make these items, draw them with few wrinkles.

Basic shape and creases

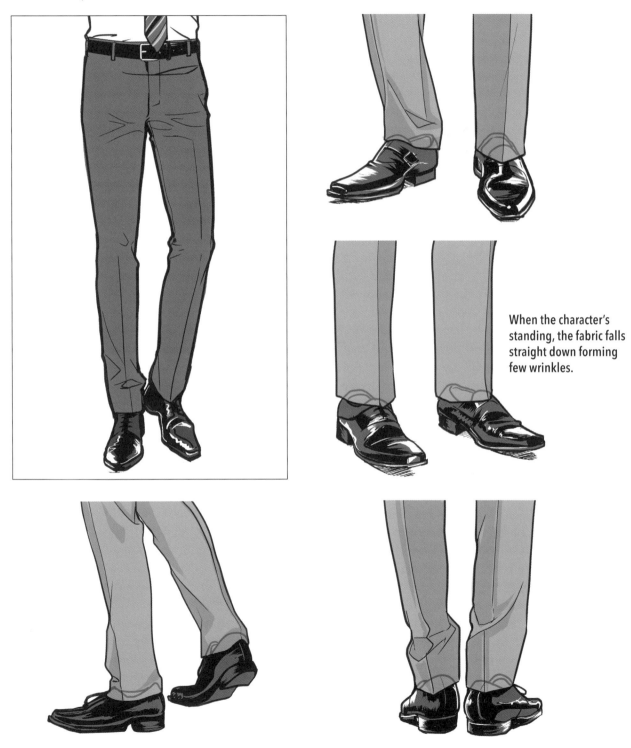

When the character's standing, the fabric falls straight down forming few wrinkles.

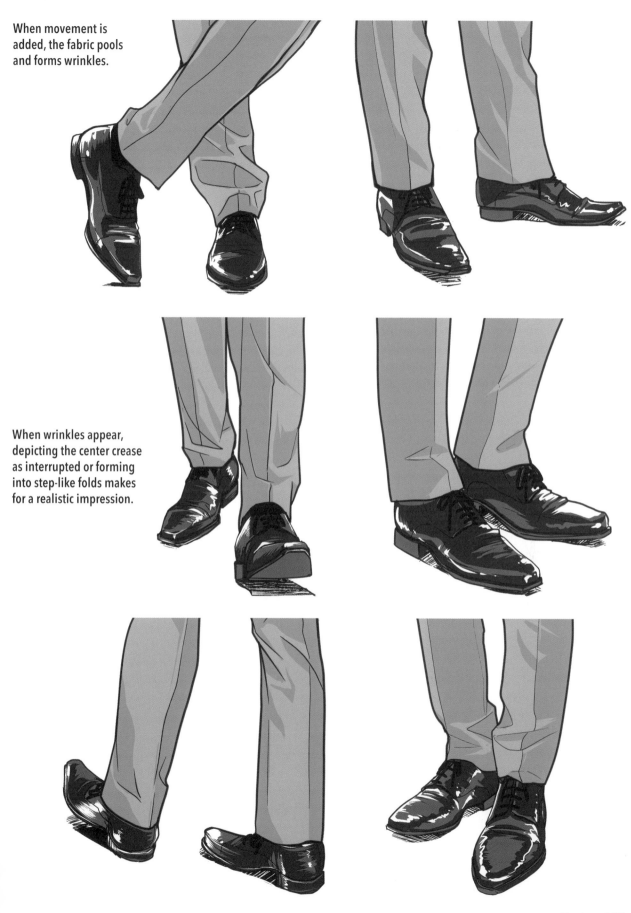

When movement is added, the fabric pools and forms wrinkles.

When wrinkles appear, depicting the center crease as interrupted or forming into step-like folds makes for a realistic impression.

Differences in shapes of pants

The shape and fit of a pair of pants says a lot about your characters. You'll have fun choosing the type that suits your creations best.

⊚ Differences in width and inseam

Whether the inseam is long or short significantly alters the impression a pair of pants makes. Pants with tucks that are roomy around the hips usually have regular or wide-cut legs.

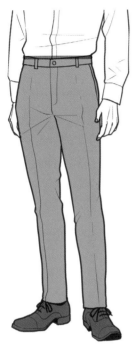

No tucks
Slim relaxed fit (high waist)

Pants with a long inseam: as there's a lot of vertical surface area, the legs appear longer.

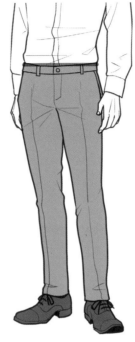

No tucks
Slim relaxed fit (low waist)

Pants with a short inseam: they create a neat waistline and give off an impression of lightness.

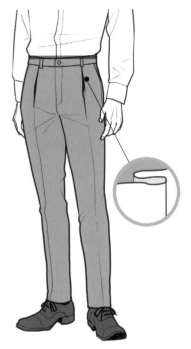

One-tuck

By creating tucks around the waistline, this style brings some roominess to the waist area, with regular to wide legs.

⊚ Differences in length

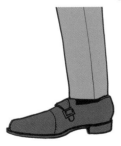

No cushion

The pants touch the shoes and conceal the socks. This length suits lightweight, slim-fitting pants.

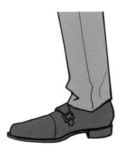

Half-cushion

The hems sit over the shoes and are at a length that they create a slight crease due to the fabric folding. This length suits slim to regular pants.

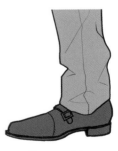

One cushion

The hems sit over the shoes and creates folded creases. This length suits regular to wide-legged pants.

Getting the pockets right

When your character's in motion, pants pockets tend to drift or move upward. It might seem like trivial detail, but if this is drawn correctly, it'll add to the realistic, dimensional look of the slacks.

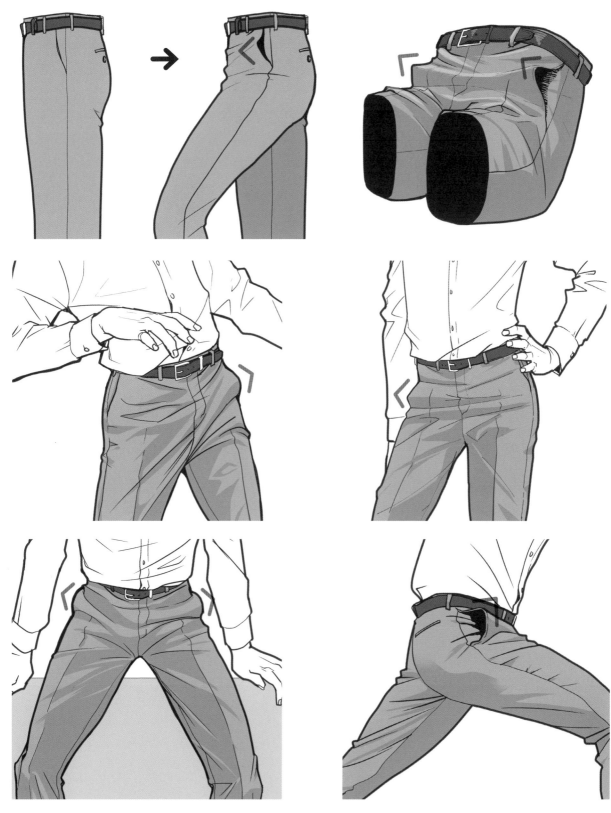

Standing poses from various angles

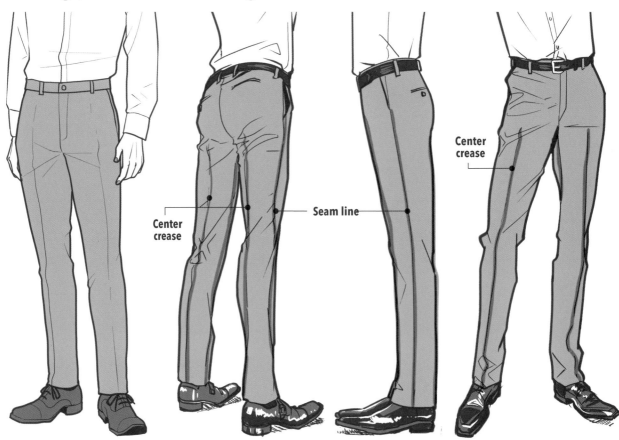

Center crease

Seam line

Center crease

The center creases are not only visible in the front, but also in the back. The seam line is not interrupted by the folds, but the center crease lines aren't detectable when fabric is taut or when it forms into folds.

KEY POINT

Baggy pants work for some characters

Dressing in oversized pants can create a sloppy and unrefined or highly casual and informal impression. If slim pants are too long, wrinkles form in the hems and make them look loose. Depending on the character's taste or preferences, this laid-back look may work.

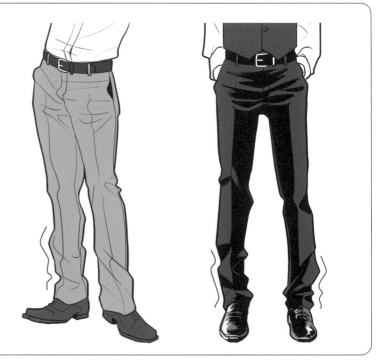

Poses & movements

For creased pants, the line of the fold runs along the very front of the character's body. When a character's seated or when the legs are crossed, the hems rise up and the socks are visible.

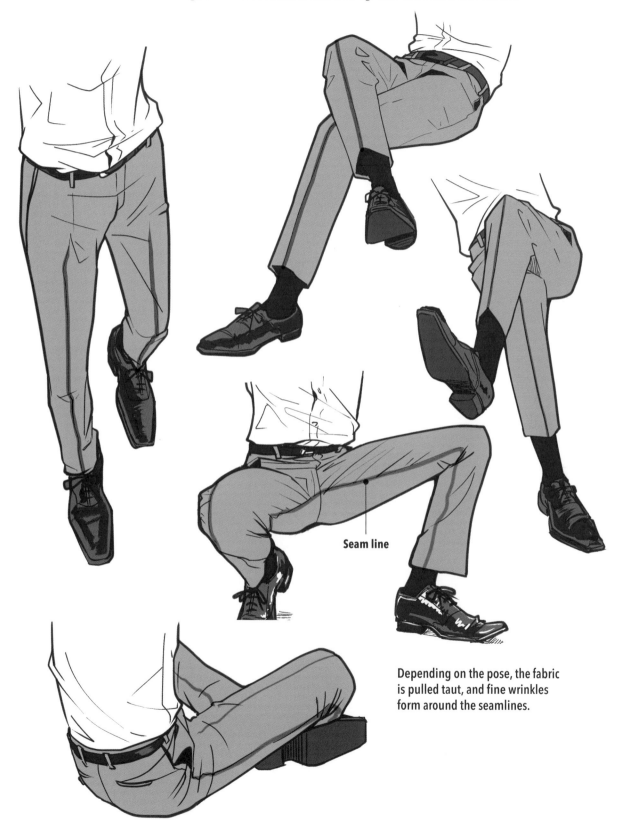

Seam line

Depending on the pose, the fabric is pulled taut, and fine wrinkles form around the seamlines.

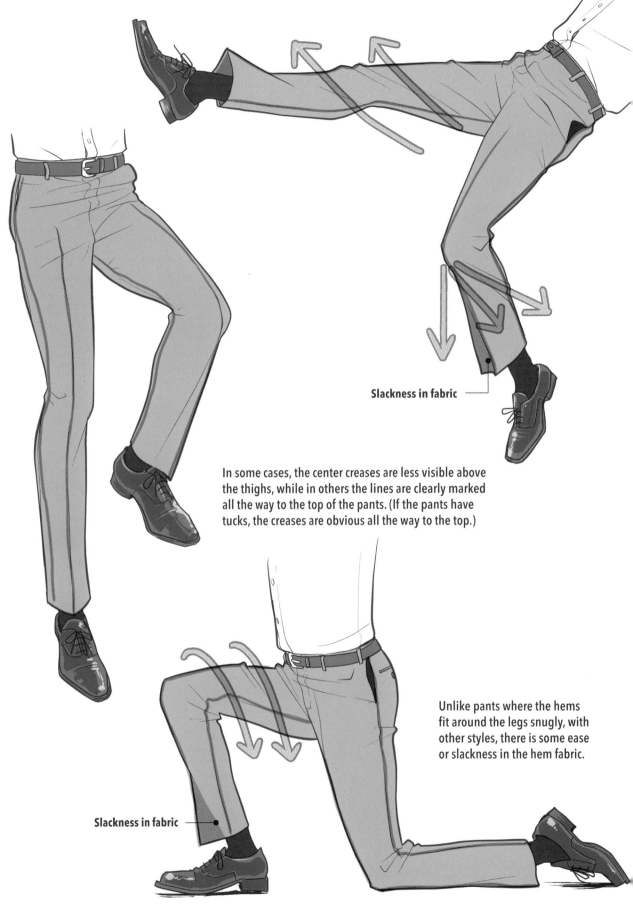

Slackness in fabric

In some cases, the center creases are less visible above the thighs, while in others the lines are clearly marked all the way to the top of the pants. (If the pants have tucks, the creases are obvious all the way to the top.)

Unlike pants where the hems fit around the legs snugly, with other styles, there is some ease or slackness in the hem fabric.

Slackness in fabric

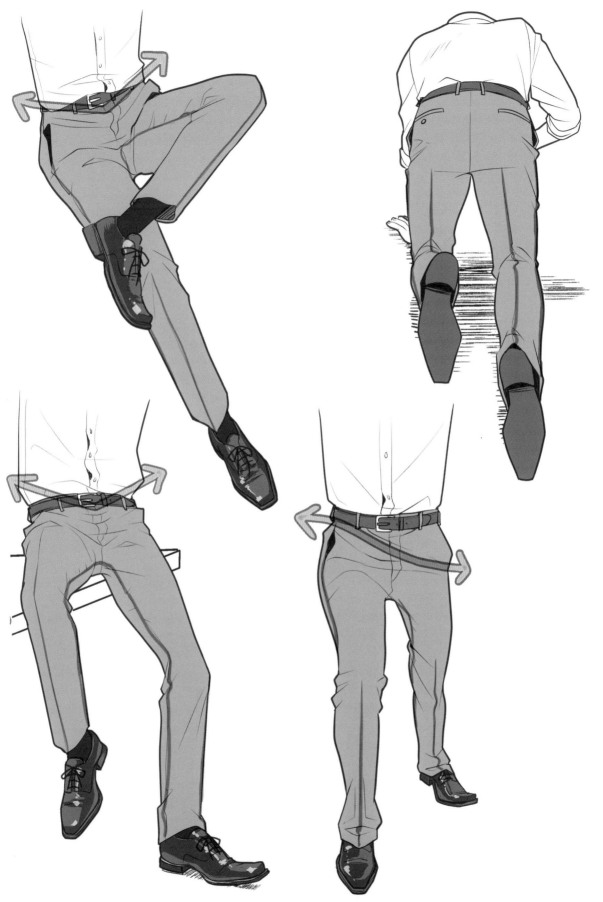

Business Shoes

Casual styles predominate, but a simple grasp of the classic dress shoe is essential. Why? It's an adaptable form that can be used as the base framework for any number of looks, styles or designs.

Basics of business shoes

⊘ Wingtip/laceup/dress shoe

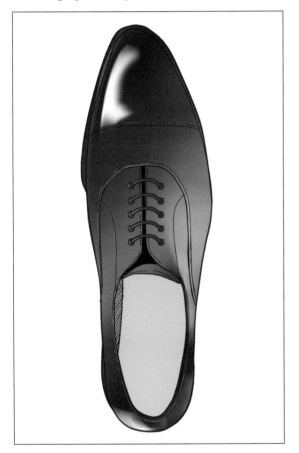

Laceups

Shoes with straight stitching on the instep, they can be worn for both formal and everyday business occasions.

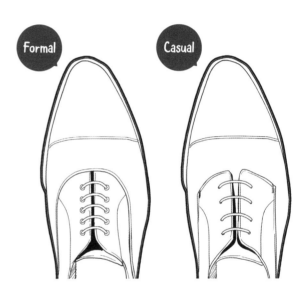

Monk strap shoes

Originally worn by monks, these shoes fasten with buckles that also add both a design accent and a sense of playfulness.

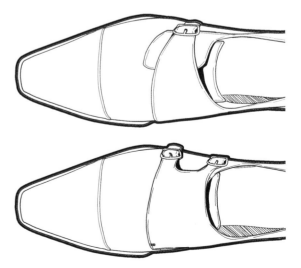

Wingtip

Simple shoes with no stitching or decoration on the upper, they're standard in business settings and common at weddings and formal events.

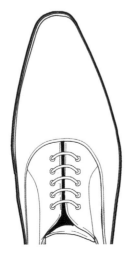

⊙ A look at toes

Round toe
The standard design, if you're not sure what kind of toe shape to draw, we recommend starting with this one.

Square toe
Shoes with a square-shaped toe section, this stylish and classic design was introduced by Italian shoemakers.

Long nose
A fashionable design with a long, narrow toe section. The pointy design make them more suitable for casual wear.

⊙ Outsole detailing
The part at the front that protrudes slightly around the edges is called the outsole. There are many types of detail, so check out these examples.

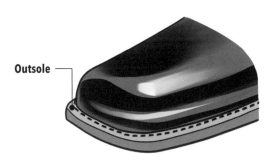

Outsole

Flat welt
A thin piece of leather is sewn flat between the upper (the leather part of the shoe) and the outsole (the sole). This is the most popular and common detail.

Storm welt
The welt is solidly sewn between the upper and the outsole in a raised formation, making it difficult for rainwater or snow to get in.

⊙ Number of eyelets
Shoelaces are generally passed through the eyelets to create parallel single lacing. Four to five per side are the usual number of eyelets, however, in styles such as a V-front with short facings, there may be fewer eyelets.

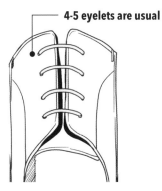

4-5 eyelets are usual

Some have fewer eyelets (the picture shows a V-front)

⊙ Selecting to suit the situation

When creating specific scenes for manga or anime, don't forget the footwear. The shoes on your characters' feet are the memorable finishing touch that completes their looks.

Formal ⟷ **Casual**

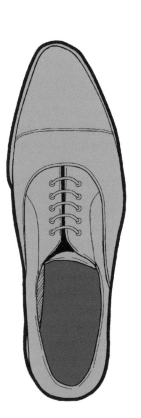 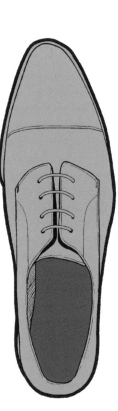 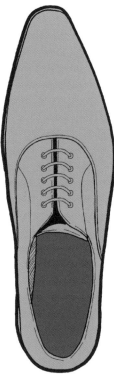 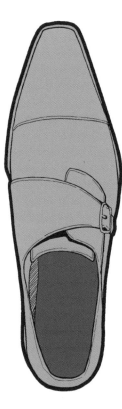

Straight tip (facings enclosed)

As the facings are enclosed, the shoes have a refined look appropriate for weddings, funerals, ceremonies and other formal occasions.

Straight tip (facings exposed)

As the facings are exposed, these shoes are easy to put on and take off. They can be used for formal occasions as well as business casual situations.

Plain toe

As formal as the straight tip, they come with both enclosed and exposed facings, the former being the more formal.

Monk strap

Slightly more casual business shoes. For everyday business settings, these are fine.

What would your character wear?

When you want to choose shoes that really match your character's personality, why not try using some of these variations?

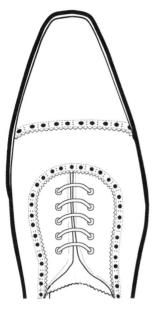

Quarter brogue

Shoes with a horizontal line of decorative holes. Compared with straight tip or plain toe shoes, they're more decorative and eye-catching.

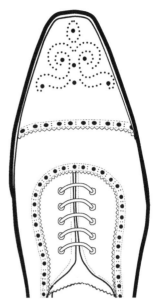

Semi brogue

Shoes with a horizontal line of decorative holes as well as decoration on the toes, they're even more ornate than the quarter brogue.

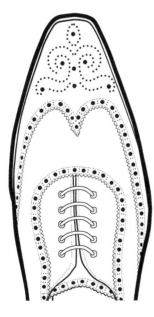

Wing tip (full brogue)

Shoes with decorative holes in a W formation on the toe as well as various decorations in other parts.

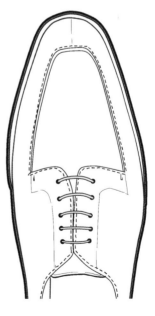

U tip

Shoes with a U-shaped design on the toe. They can be used in both business and casual situations.

Basic drawing method

⊙ Shoe sole

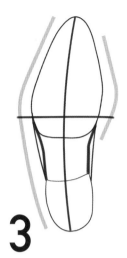

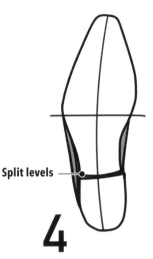

Split levels

1
Draw a cross. Make the vertical line curve slightly on the inside edge.

2
Draw the front, center and heel of the shoe separately and connect them to block in the overall shape.

3
Adjust the shape, keeping in mind that the arch on the inside edge creates a stronger indentation, with the outer edge forming a smooth line.

4
Viewed from the sole, the outer side of the leather upper is slightly visible, so add that detail and use black to emphasize the differences in levels between the sole and heel.

⊙ Overhead view

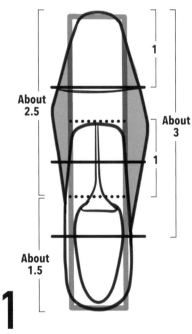

About 2.5

About 3

1

1

About 1.5

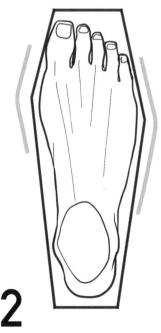

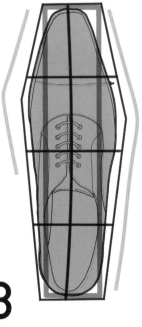

1
The proportions of actual shoe parts vary depending on the design, but when drawing an illustration, it's easier to use the proportions above as a rough guide.

2
Block in the outer edge of the shoe, keeping the shape of the foot in mind. The big toe joint protrudes, while the line from the little toe to the heel is smooth.

3
Make the line that passes through the center of the shoe curve slightly to the inside edge. The outsole is visible at the front of the shoe, so don't forget that detail.

⊗ Side view/View from an angle (outer side)

1

Block in the shoe in three parts (front, center and back). Block in the shoelaces in the center section.

2

Draw in the shoe silhouette, giving it a roundness. In the picture where the shoe is on an angle, it's a good idea to draw in a guide line where the shoe touches the ground.

3

Slightly raise the toe of the shoe. Making it lift up just a little is fine and gives the shoe a more realistic look.

4

Draw in the shoelaces and facings. Add in shadows beneath the shoes to impart a sense of solidity.

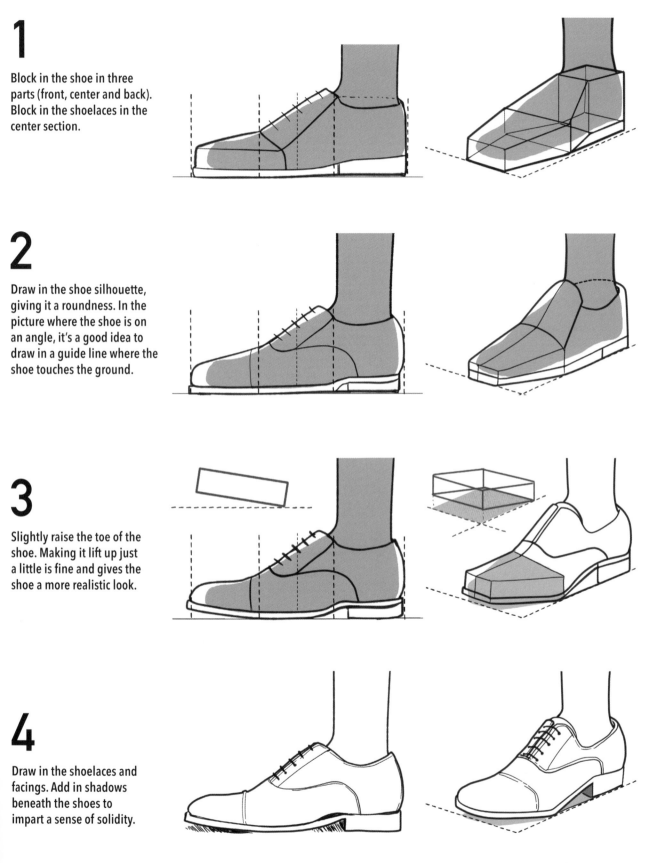

⊙ View from an angle (inner side and back)

1

Draft the shoe using three blocks.

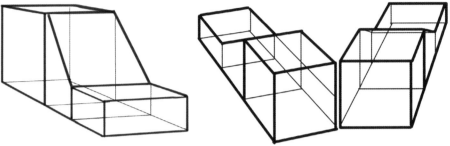

2

Use the blocking in to draw the shoe's silhouette. Draw guide lines on the ground in advance and make sure that the shoes don't lift off the ground. Don't draw in the shape of the front edge yet.

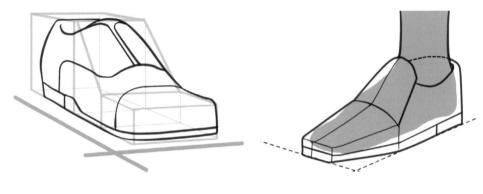

3

Slightly raise the toe section off the ground. At this point, adjust the shape of the toe and make it narrower.

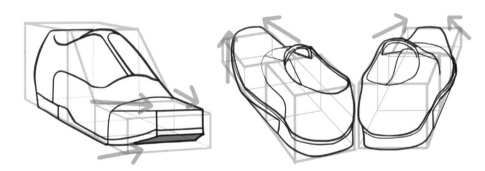

4

Add in details such as the shoelaces. If you're still struggling with the overall shape of the shoe, try drawing a simplified version instead.

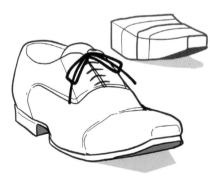
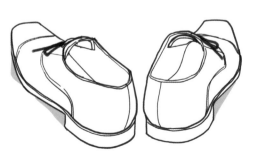

Various movements and poses

Depending on the character's movements, the upper or the sole of the shoe is visible. Sometimes, if the shape becomes distorted, it can seem complicated. If you're having trouble, create a simplified box or draw only the sole first in order to get a better understanding of the shape.

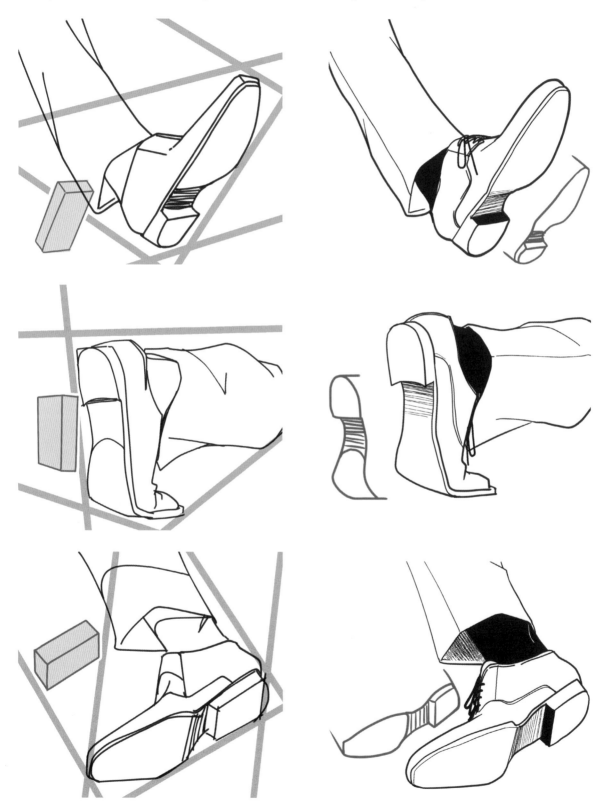

Here are line drawings of only the shoes from the poses shown on page 115. The trick to capturing natural-looking shoes is to have a grasp of the shape of the mouth of the shoe where it's covered by the pants.

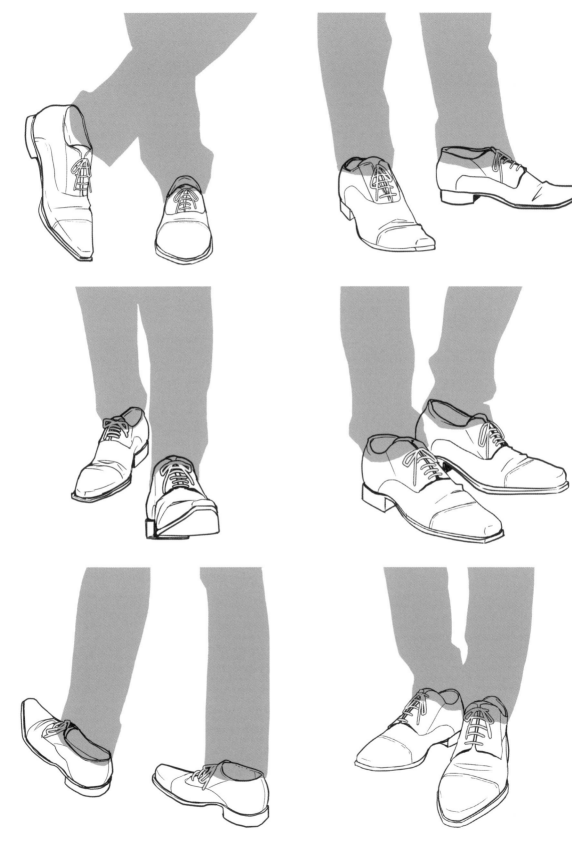

Shoes to suit your characters

Here, let's take a look at some examples of shoes selected to suit characters. These are some obvious pairings. Why not mix it up and give your character a mismatched look or, better yet, a signature style?

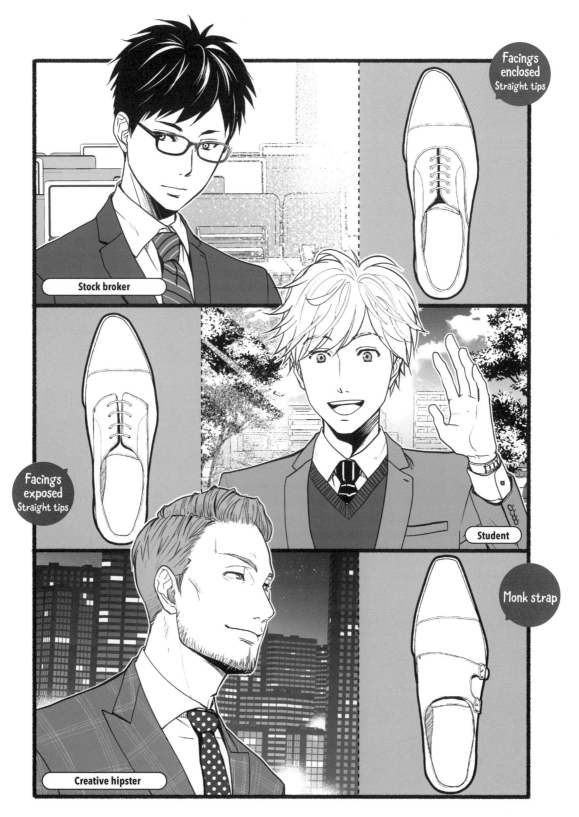

Facings enclosed
Straight tips

Stock broker

Facings exposed
Straight tips

Student

Monk strap

Creative hipster

Women's Business Wear

The traditional look centers on tailored, tight-fitting skirt suits. The blouse is a classic staple and offers you a blank slate on which to layer style and design elements.

Basic jacket and shirt

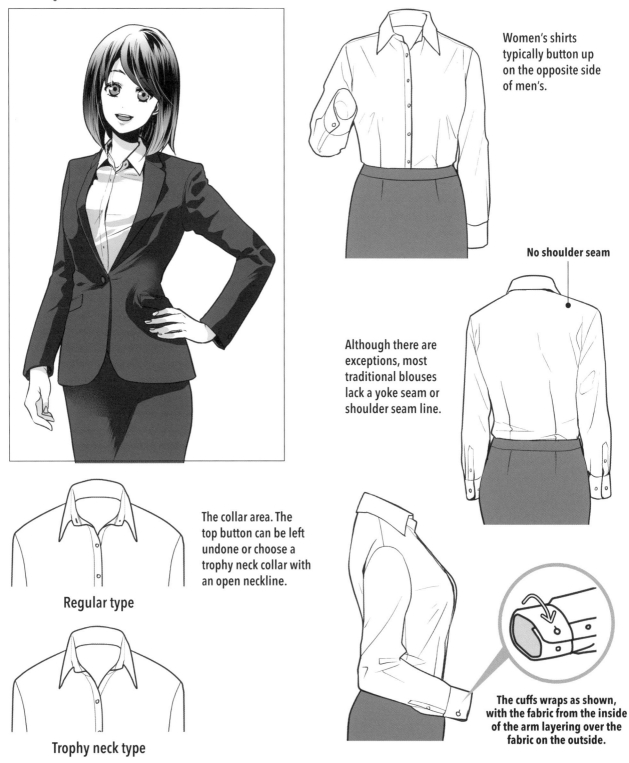

Women's shirts typically button up on the opposite side of men's.

No shoulder seam

Although there are exceptions, most traditional blouses lack a yoke seam or shoulder seam line.

Regular type

The collar area. The top button can be left undone or choose a trophy neck collar with an open neckline.

Trophy neck type

The cuffs wraps as shown, with the fabric from the inside of the arm layering over the fabric on the outside.

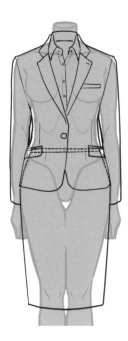

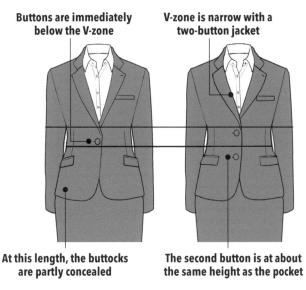

Buttons are immediately below the V-zone

V-zone is narrow with a two-button jacket

At this length, the buttocks are partly concealed

The second button is at about the same height as the pocket

Jackets and blazers mainly have one or two buttons. The first button is immediately below the V-zone. On a two-button jacket, think of the second button as being about the same height as the pocket (around the hip bone) to make it easier to draw.

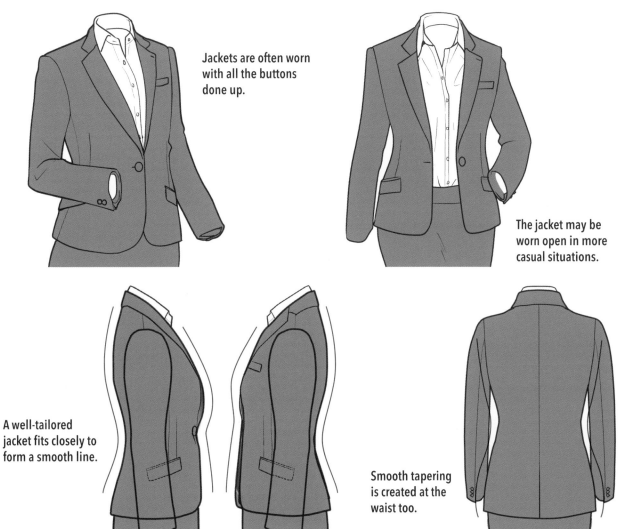

Jackets are often worn with all the buttons done up.

The jacket may be worn open in more casual situations.

A well-tailored jacket fits closely to form a smooth line.

Smooth tapering is created at the waist too.

Differences between men's and women's wear

With manga, anime and cosplay, where originality is key, there are no rules, especially when it comes to what are traditionally seen as "gendered" garments. Mix and match, let your characters find their unique looks. So it's helpful to have an understanding of the basics when you want to create distinctive looks.

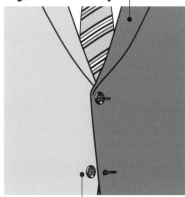

On men's clothing, the fronts form a y.

For men's two-button suits, leave the lowest button undone

On a two-button suit, leave the bottom button undone. Three-button suits can be worn with the top two buttons fastened or only the middle button fastened.

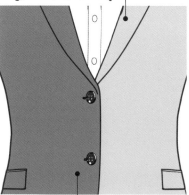

On women's clothing, the fronts form a γ.

For women's suits, do up all the buttons

Women's jackets and shirts fasten on the opposite side from men's. It's commonly worn buttoned with the jacket left fastened when the character is seated in a chair.

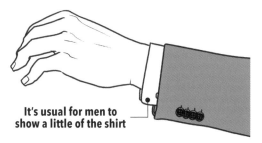

It's usual for men to show a little of the shirt

For men's styles, a little bit of the shirt is exposed from beneath the jacket sleeve.

It's usual for women not to show the shirt

However, many women's styles are sleeveless or ¾-length sleeves, so it's of course O.K. to draw the jacket without showing the shirt sleeve.

How to draw pumps

The standard, traditional shoes for women's business wear are pumps. The height of the heel changes the impression that the character makes.

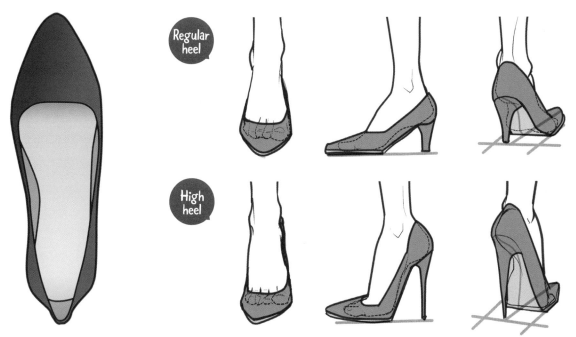

Regular heel

High heel

The trick to drawing pumps is to block in their contact area with the ground. Check that the toe section and heel are both on the same plane (in a walking pose, the heel may lift off the ground).

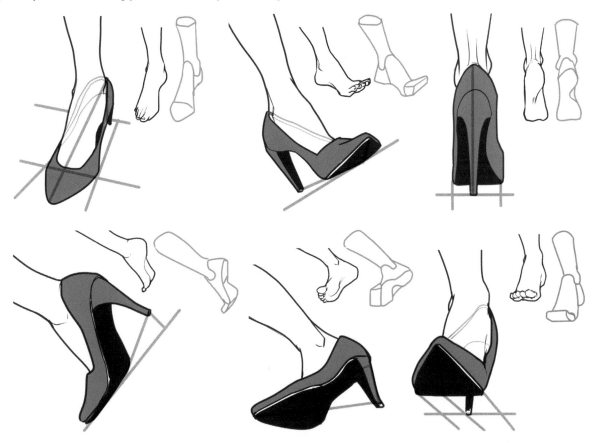

Basic shapes and creases in tight skirts

Tight skirts fit the body closely and form slightly rigid creases when a character moves. Here's a range of examples of how the shape and creases change form when the legs are in motion.

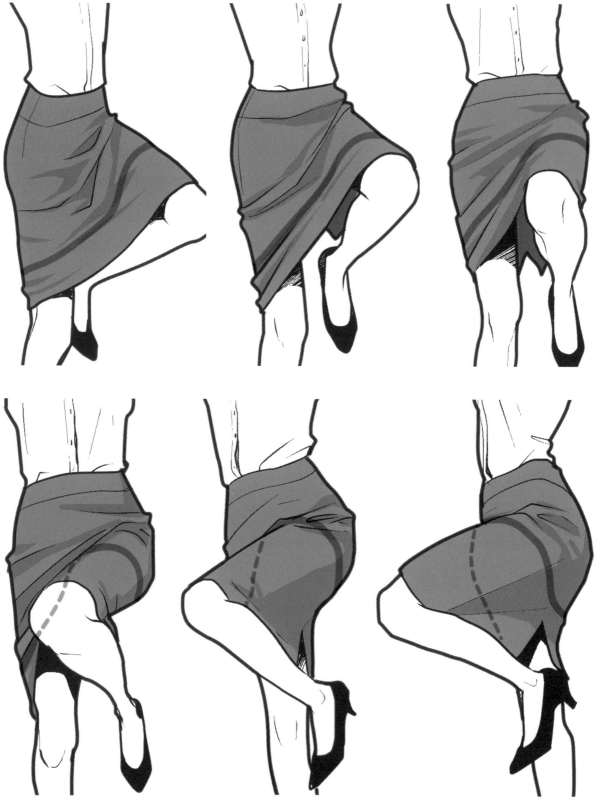

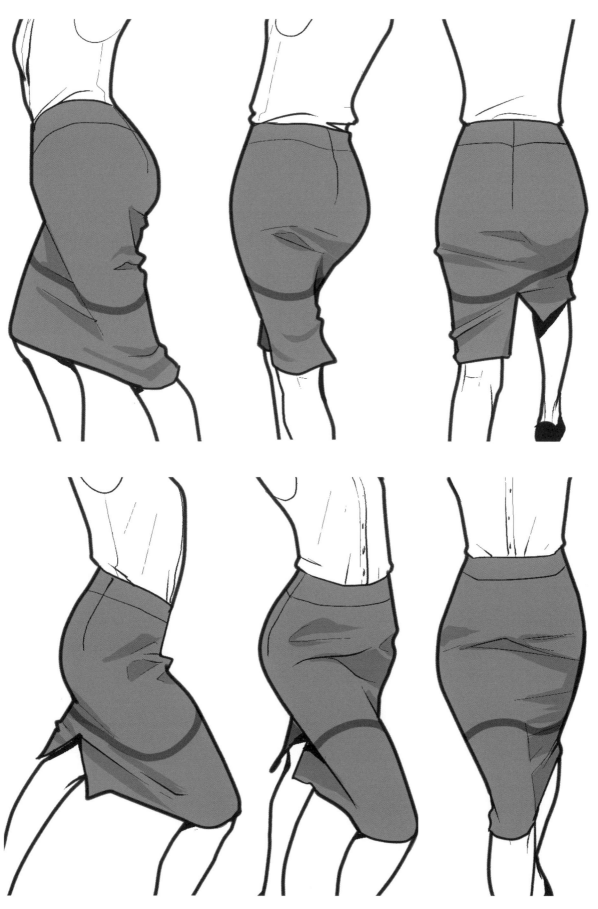

Movements and poses

Business wear can seem stiff, but creating poses that emphasize the lines of the often form-fitting garments allows for a range of expression.

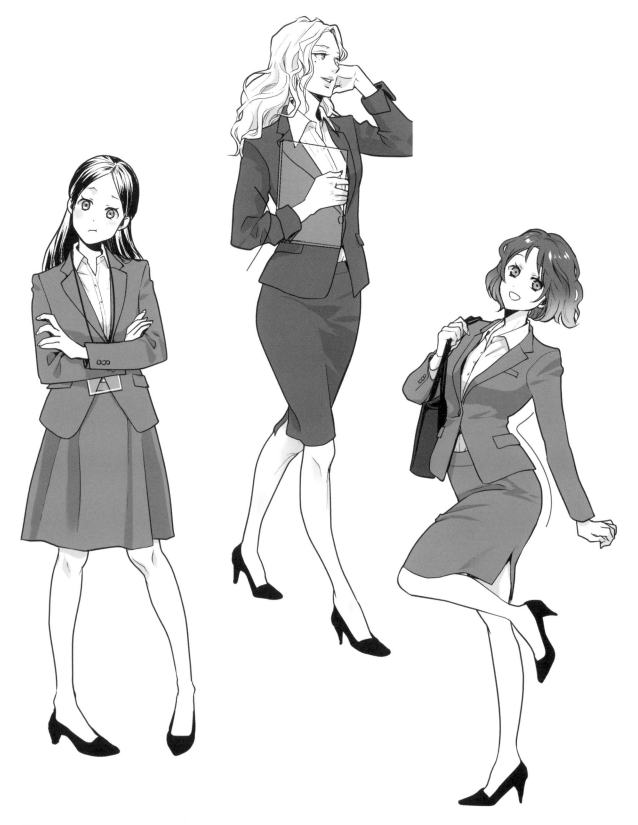

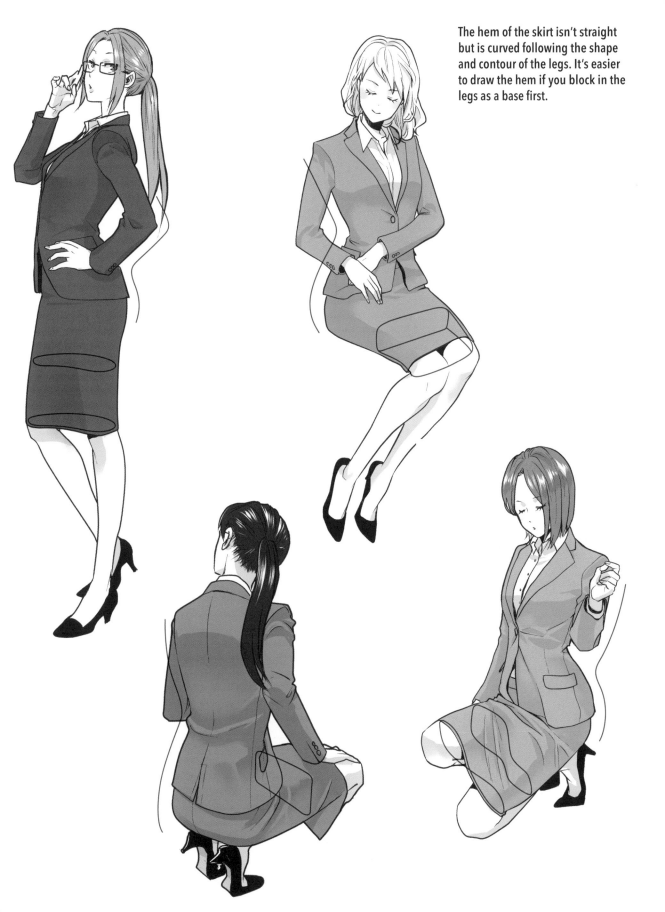

The hem of the skirt isn't straight but is curved following the shape and contour of the legs. It's easier to draw the hem if you block in the legs as a base first.

Use shading and tone instead of lines to suggest the folds and wrinkles caused by motion.

When drawing pants, a tapered, form-fitting leg creates a clean, neat impression.

School Wear

If you're creating school-aged characters, then a uniform is a great
go-to option. Or how about a sailor suit as the basis for a compelling
cosplay creation? Then *you'll* be the character who's turning heads.

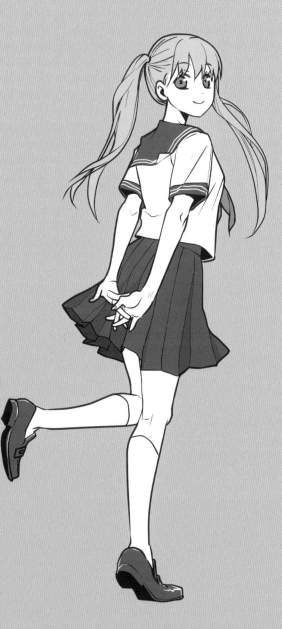

Boys' Uniforms (Gakurans)

A fun and fluid design, the gakuran is the standard boys' uniform. Its design is very similar to that of a suit, but the shape around the collar is different, so capturing that distinctive element will give it an authentic look.

Basic shape and creases

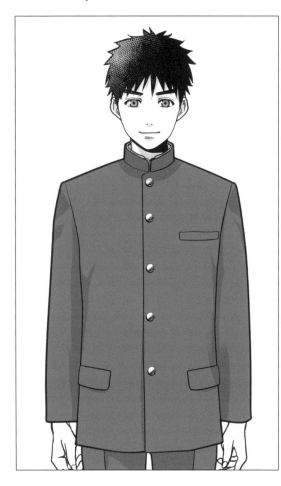

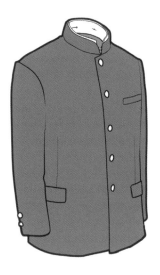

It's usual for the blazer to have five buttons down the front. Unlike a suit, it's worn with the buttons fastened all the way to the bottom.

The jacket usually doesn't have the split in the back called the back vent.

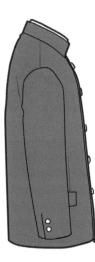

Two buttons on the sleeves are usual, but some versions have only one or none at all.

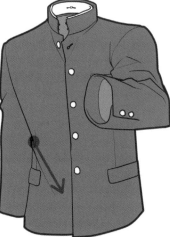

Some students prefer to leave the collar unhooked or the first button open.

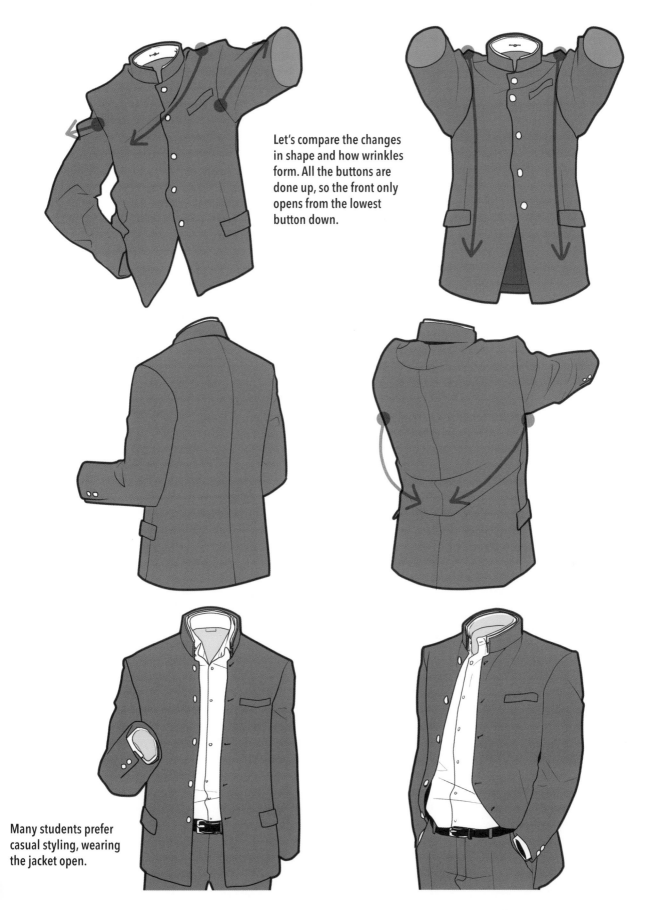

Let's compare the changes in shape and how wrinkles form. All the buttons are done up, so the front only opens from the lowest button down.

Many students prefer casual styling, wearing the jacket open.

Summer uniform with a shirt

A shirt makes for a casual summer alternative to the more formal winter version. It's typically tucked into the pants, but some students wear it loose.

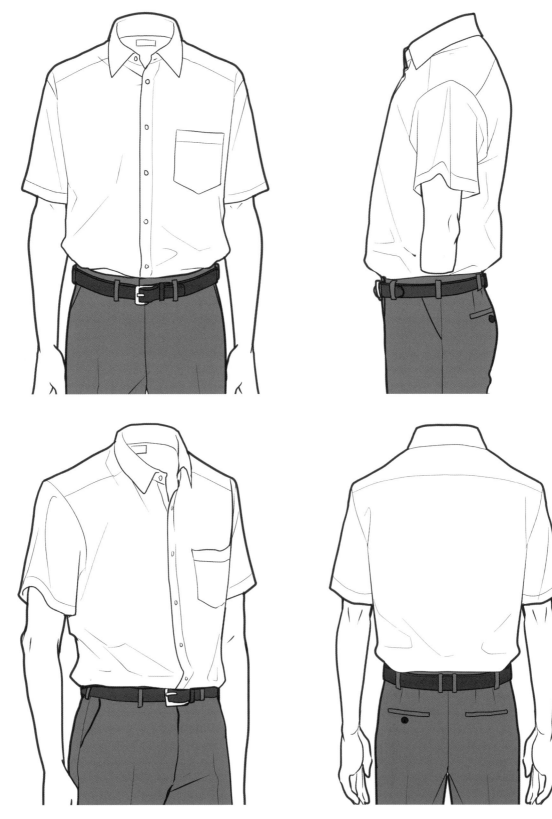

Collar construction

The stand collar is made from a long, narrow piece of material that encircles the neck. Make sure the shoulder line and the line below the collar match up.

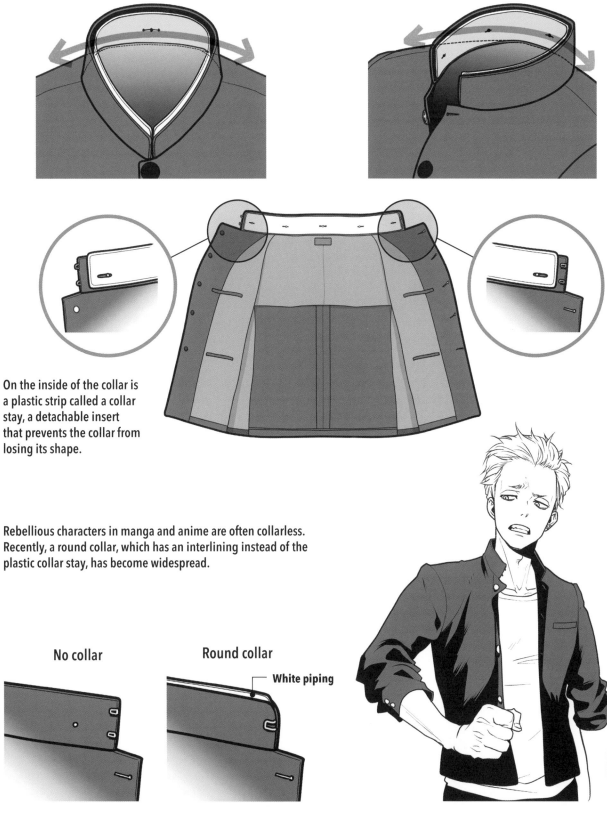

On the inside of the collar is a plastic strip called a collar stay, a detachable insert that prevents the collar from losing its shape.

Rebellious characters in manga and anime are often collarless. Recently, a round collar, which has an interlining instead of the plastic collar stay, has become widespread.

No collar

Round collar

White piping

Movements and poses

As the suit is usually made from black fabric, some effort is required to accurately depict folds and wrinkles. Coloring the fabric gray and then painting the areas where shadows form in black adds depth and dimensionality.

Sailor Uniform

This uniform is characterized by its large collar. Let's take a look at the shirt, along with the pleated skirts which can present a challenge with its layered effects.

Basic shape and creases

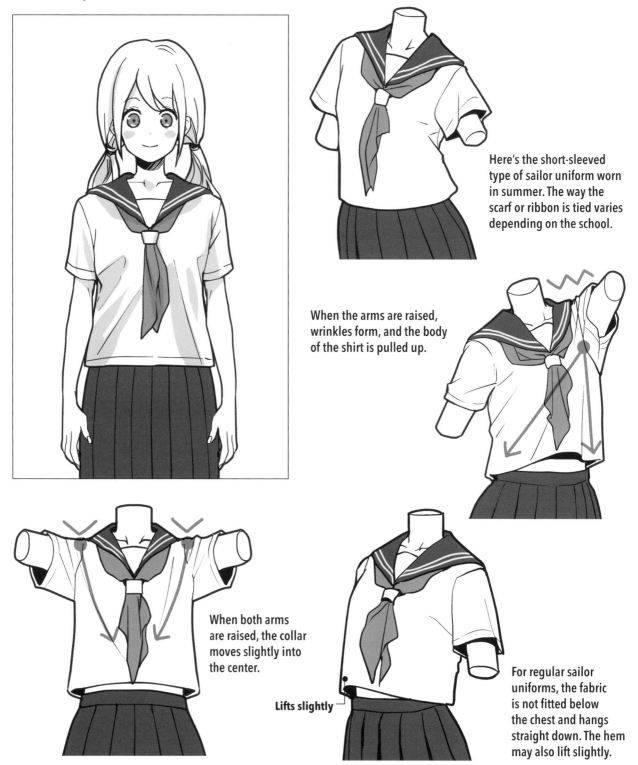

Here's the short-sleeved type of sailor uniform worn in summer. The way the scarf or ribbon is tied varies depending on the school.

When the arms are raised, wrinkles form, and the body of the shirt is pulled up.

When both arms are raised, the collar moves slightly into the center.

Lifts slightly

For regular sailor uniforms, the fabric is not fitted below the chest and hangs straight down. The hem may also lift slightly.

The sailor uniform is defined by the large collar covering the shoulders from front to back.

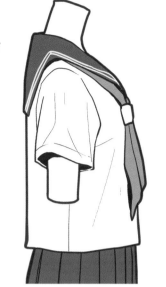

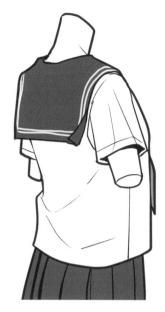

The back of the square collar sometimes flips up in the breeze.

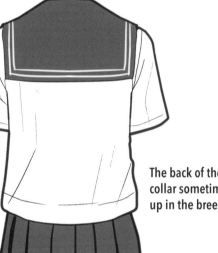

When the arm is raised, the collar lifts along with the body of the uniform.

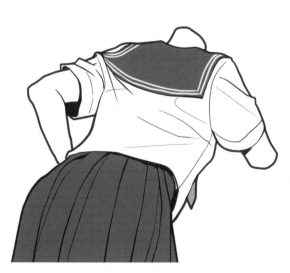

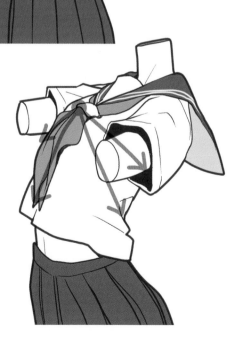

Collar shapes

The large collar of the sailor uniform is made from fabric that's separate from the bodice, and the square-shaped section at the back flips up. Look at these various versions and permutations of the collar for a better understanding of its construction.

Down

Up

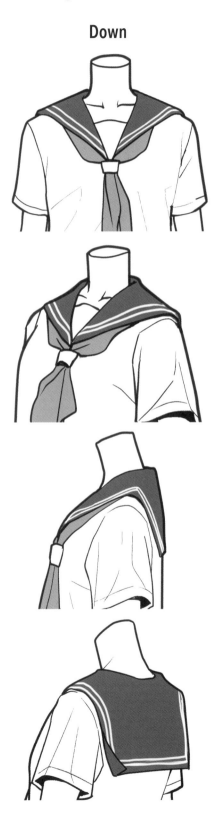
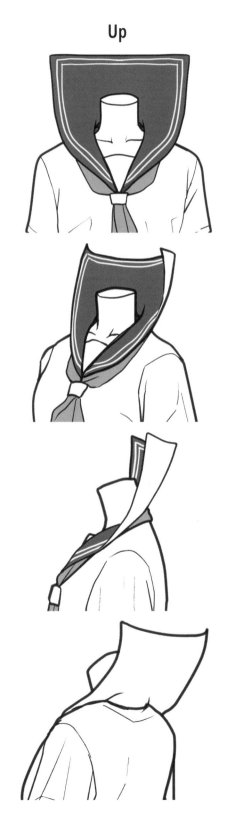

Collars from different perspectives. For variety, why not show the back of the collar flipped up?

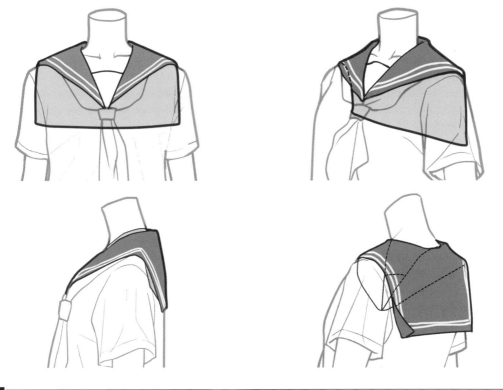

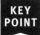 KEY POINT

Various designs

Uniform designs vary, with some having bows at the front instead of scarves. Additionally, some fasten at the side, while others zip at the front.

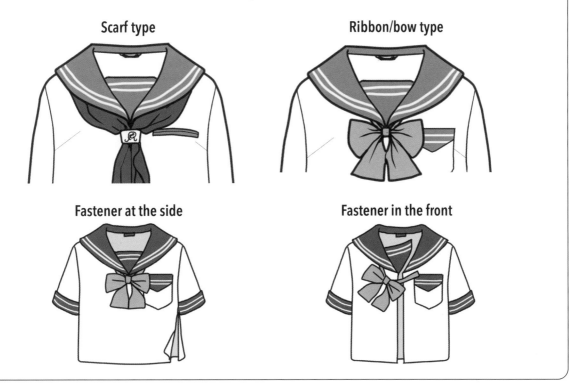

Scarf type

Ribbon/bow type

Fastener at the side

Fastener in the front

Expressing dimensionality

When drawing a sailor collar viewed directly from the front, if it seems to lack a sense of dimension or looks flat, consider the following points.

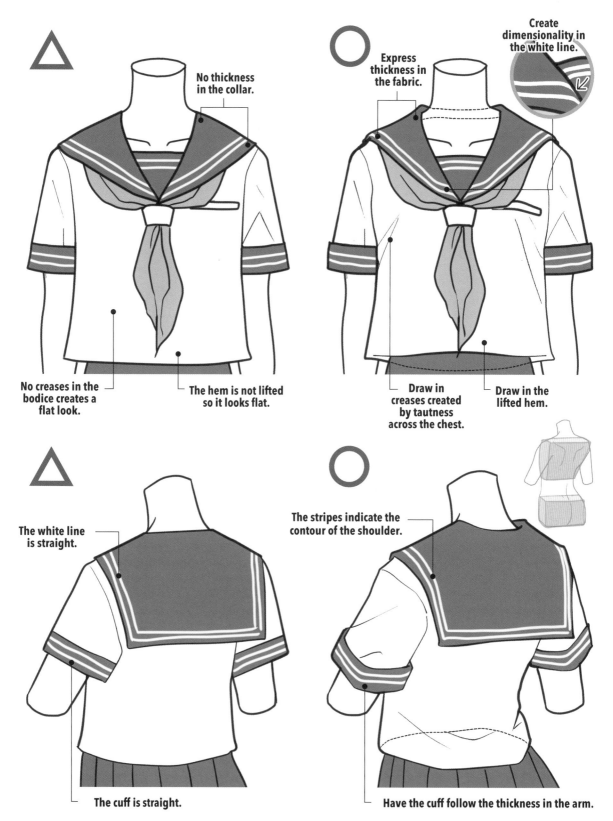

No thickness in the collar.

Express thickness in the fabric.

Create dimensionality in the white line.

No creases in the bodice creates a flat look.

The hem is not lifted so it looks flat.

Draw in creases created by tautness across the chest.

Draw in the lifted hem.

The white line is straight.

The stripes indicate the contour of the shoulder.

The cuff is straight.

Have the cuff follow the thickness in the arm.

When viewing a character from a standard angle from behind, there's a curve to the sleeves. The folds of the skirt should not be drawn in a straight line, but curved to match the shape of the hips for a more three-dimensional effect.

From an overhead angle, the sleeves, bodice and skirt hem curve downward.

When seen from below, the sleeves, bodice and skirt hem curve upward.

Long-sleeved version

Drawing summer and winter uniforms allows for the expression of seasonality. The examples here show the long-sleeved sailor uniform worn in winter. Depending on the school, a between-seasons uniform to bridge the summer and winter may be worn.

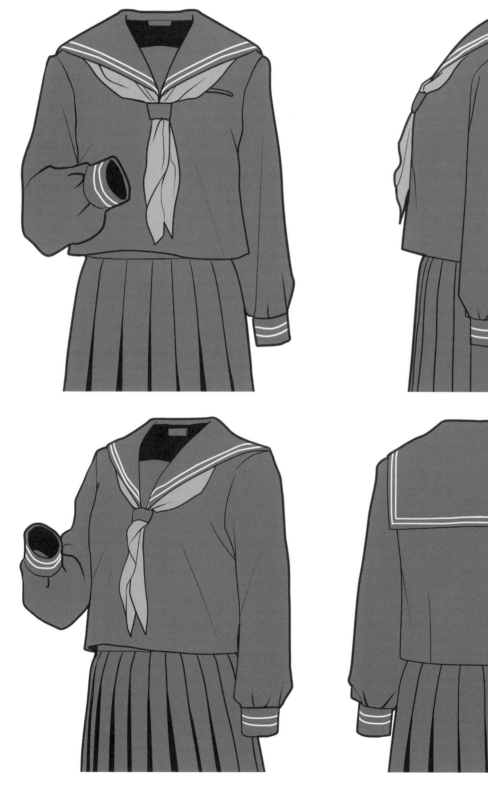

Pleated skirt construction

Pleats can be difficult to draw, but once you understand their construction, it becomes easier.

Pleats fold to the left

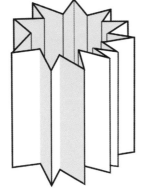

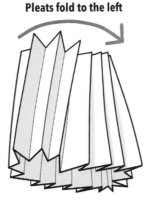

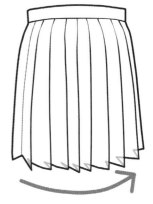

A typical pleated skirt has folds that fall to the left, falling counter-clockwise when viewed from above.

The pleats of the skirt fan out when the character moves. The gaps between the zigzags in the hem become larger.

> **KEY POINT**
>
> ## The direction of the pleats doesn't change in the back
>
> In a typical pleated skirt, the pleats fall counter-clockwise. This is the same in the back of the figure. For digital illustrations, be careful not to inadvertently leave the image as-is after flipping it.

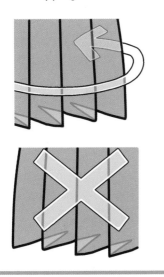

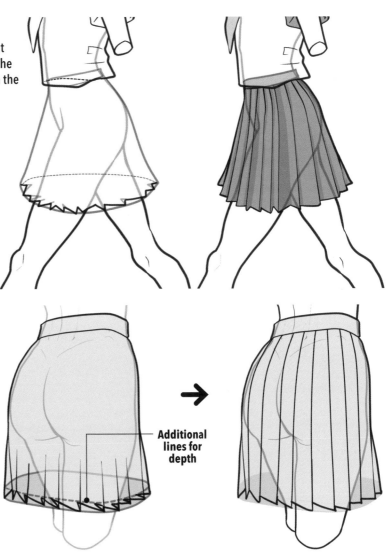

Additional lines for depth

Start by blocking in a shape with no pleats, then add lines to indicate depth and work in the zigzags of the pleats between the gaps in the lines.

Skirt movement and flow

The shape of a skirt alters dramatically in relation to a character's movements and gestures. The shape becomes extremely distorted in crouching or seated poses, so start by drawing a simplified picture to grasp that particular shape.

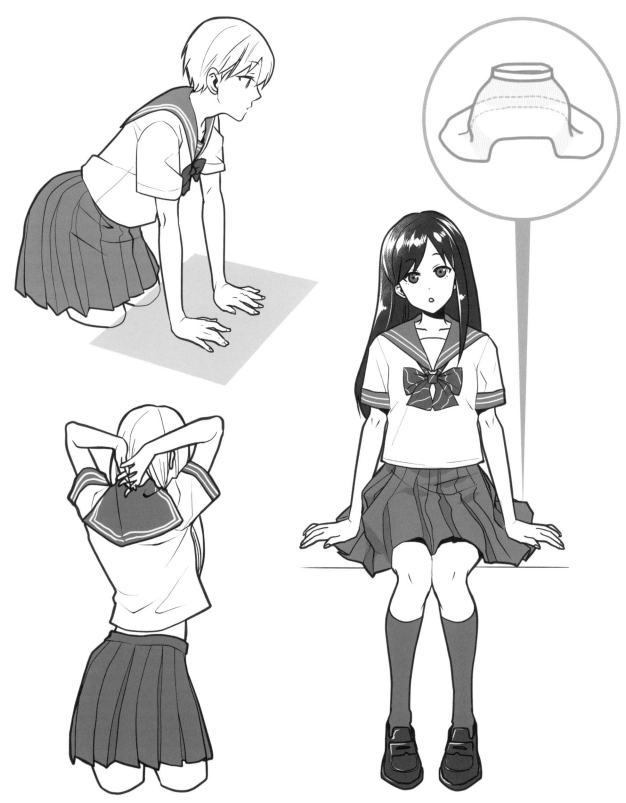

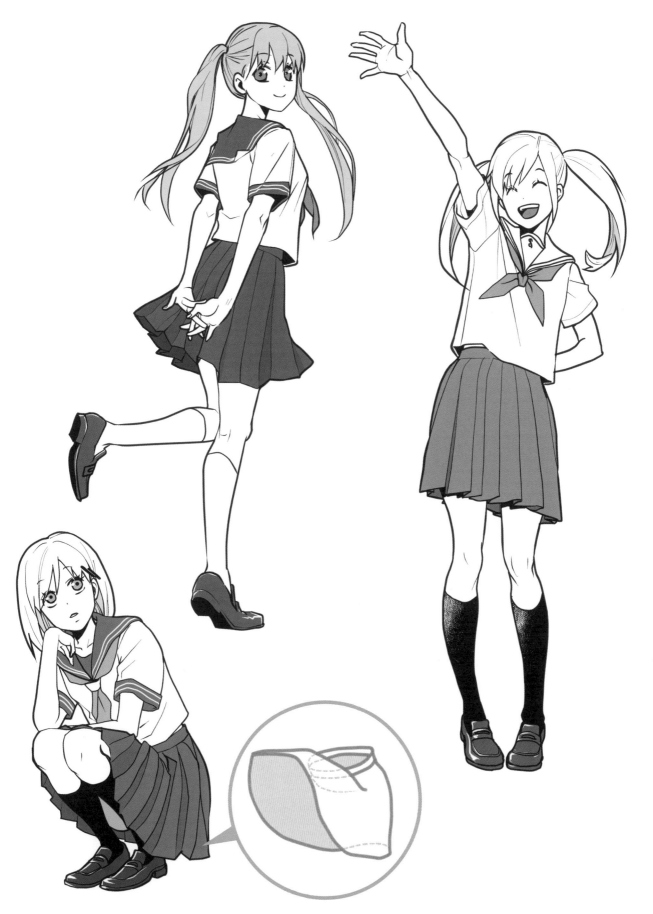

Final Thoughts

I started writing this book with the goal of creating a single volume as a quick reference for drawing all kinds of clothes well.

When drawing clothes for characters in manga and anime, there's no need to become an apparel expert. Rather than the rules for actual clothing, creating outfits and ensembles that suit your character and reflect the scene is what's most important.

These days, there are a lot of specialist books related to clothing, and there is information all over the internet. But I still have trouble finding the information I want. So I started working on this book. As the aim is to draw clothing that lively, active characters are wearing, I've provided explanations of how to bring dimension to clothing and how to match it to characters' movements.

In producing this book, I received a lot of guidance from fashion designer and instructor Unsetsu. He showed me various items of actual clothing, generously giving me detailed insights from the unique perspective of someone who works with apparel. I'd like to take the opportunity to express my gratitude to him for the hands-on experience.

The methods presented in this book are only for drawing basic clothing. To discover methods for depicting more original attire, you will need to delve deeper.

There is so much joy in one's own stylishly dressed characters taking their place in the worlds of manga, anime and cosplay. I sincerely hope to help as many people as possible experience such stylish joy!

Author: Rabimaru

Active as an illustrator, Rabimaru also publishes tips online about drawing clothing. Extremely popular, her tips published on Twitter received 50,000 retweets. She publishes clothing drawing methods that even beginners can learn easily on pixiv FANBOX.

pixivID: 1525713
Twitter: @rabimaru_t

When creating signature styles, outfits and costumes for your characters (or yourself), it's important to pose some key questions. What shape are the shoulders or the collar, and how are the buttons positioned? What kind of silhouette is created by the clothing you want to draw? What kind of line do the pants create and what are the hems like?

I'm the principal instructor and administrator at Masa Mode Academy of Art, an illustration school in Osaka. At the school, our teaching is centered on fashion illustration, but even when it comes to manga- or anime-style illustrations or original cosplay designs, the important foundations remain the same: know about the garments and don't simply draw what you see; draw by identifying the lines that you need.

Learn the basic styles of clothing. Remove any unnecessary items and practice over and over again to create refined designs. Turn heads, create an indelible impression. But most of all: have fun with it!

Introducing editorial supervisor Unsetsu

Principal, Masa Mode Academy of Art; Representative, Unsetsu International; Representative, Mode Illustration Research Institute

Based in Asia, Unsetsu is active internationally, presenting collections in New York; Cologne, Germany; China and other international locations. Skilfully blending East and West, he continues to offer people-friendly fashion through his Unsetsu Collection designs.

Introducing the Masa Mode Academy of Art
www.mm-art.com

An illustration school based in Tamatsukuri, Osaka. The school offers various practical courses including fashion drawing for improving sketching and a sense of fashion, live model drawing, color and composition. Offering not only fashion illustration but character illustration and character art, the school supports the next generation of creators in various artistic and design fields.

"Books to Span the East and West"

Tuttle Publishing was founded in 1832 in the small New England town of Rutland, Vermont [USA]. Our core values remain as strong today as they were then–to publish best-in-class books which bring people together one page at a time. In 1948, we established a publishing outpost in Japan–and Tuttle is now a leader in publishing English-language books about the arts, languages and cultures of Asia. The world has become a much smaller place today and Asia's economic and cultural influence has grown. Yet the need for meaningful dialogue and information about this diverse region has never been greater. Over the past seven decades, Tuttle has published thousands of books on subjects ranging from martial arts and paper crafts to language learning and literature–and our talented authors, illustrators, designers and photographers have won many prestigious awards. We welcome you to explore the wealth of information available on Asia at **www.tuttlepublishing.com**.

Published by Tuttle Publishing, an imprint of Periplus Editions (HK) Ltd.

www.tuttlepublishing.com

UGOKI TO SHIWA GA YOKUWAKARU IFUKU NO EGAKIKATA ZUKAN
Copyright © Rabimaru, UNSETSU/HOBBY JAPAN
All rights reserved.
English translation rights arranged with Hobby Japan Co., Ltd. through Japan UNI Agency, Inc., Tokyo

Library of Congress Control Number: 2023944618
ISBN 978-4-8053-1753-2
English Translation © 2024 by Periplus Editions (HK) Ltd

26 25 24 23 10 9 8 7 6 5 4 3 2 1

Printed in China 2311EP

Distributed by
North America, Latin America & Europe
Tuttle Publishing
364 Innovation Drive
North Clarendon, VT 05759-9436 U.S.A.
Tel: 1 (802) 773-8930
Fax: 1 (802) 773-6993
info@tuttlepublishing.com
www.tuttlepublishing.com

Japan
Tuttle Publishing
Yaekari Building, 3rd Floor
5-4-12 Osaki
Shinagawa-ku
Tokyo 141 0032
Tel: (81) 3 5437-0171
Fax: (81) 3 5437-0755
sales@tuttle.co.jp
www.tuttle.co.jp

Asia Pacific
Berkeley Books Pte. Ltd.
3 Kallang Sector, #04-01
Singapore 349278
Tel: (65) 67412178
Fax: (65) 67412179
inquiries@periplus.com.sg
www.tuttlepublishing.com